IMAGES
of America

DEALEY PLAZA

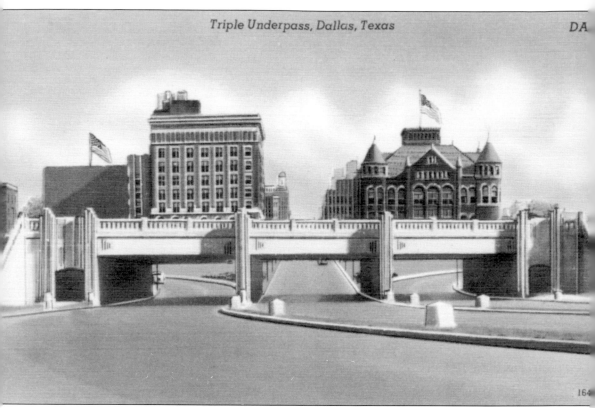

Upon its completion in 1940, Dealey Plaza projected a sense of civic pride and triumph over the crippling Great Depression of the 1930s. Postcards most reflected this new image of Dallas. (Jeff Dunn.)

ON THE COVER: Dealey Plaza, consisting of the triple underpass and a 3.1-acre city park, was the western gateway to downtown Dallas. In this view from around 1940, the opening day parade for the State Fair of Texas can be seen stretching along the length of Main Street through the central business district, toward its ultimate destination at Fair Park. (Dallas Municipal Archives.)

IMAGES
of America

DEALEY PLAZA

John H. Slate and Willis C. Winters

ARCADIA
PUBLISHING

Copyright © 2013 by John H. Slate and Willis C. Winters
ISBN 978-1-4671-3022-6

Published by Arcadia Publishing
Charleston, South Carolina

Printed in the United States of America

Library of Congress Control Number: 2013933074

For all general information, please contact Arcadia Publishing:
Telephone 843-853-2070
Fax 843-853-0044
E-mail sales@arcadiapublishing.com
For customer service and orders:
Toll-Free 1-888-313-2665

Visit us on the Internet at www.arcadiapublishing.com

*Dedicated to the pioneers of Dallas and
to the memory and ideals of Pres. John F. Kennedy.*

CONTENTS

ACKNOWLEDGMENTS

While a significant number of images are from the Dallas Municipal Archives in the City of Dallas, this book would not be complete without photographs from a number of superb archives and collections. The authors wish to thank the following individuals and institutions for their contributions to this book: Dallas Park and Recreation Department; City Secretary's Office, City of Dallas; Jerome Sims; *Dallas Morning News*; Dallas Heritage Village; Evelyn Montgomery; The Sixth Floor Museum at Dealey Plaza; Megan Bryant; Sally Rodriguez; Trent Williams; Dallas city secretary Rosa Rios; Jeff Dunn; Dallas Firefighters Museum; Texas/Dallas History and Archives, Dallas Public Library; Dallas Historical Society; Museum of the American Railroad; John F. Kennedy Presidential Library and Museum; Ochsner Hare & Hare; Texas State Archives; Library of Congress; New York Public Library; Mesa Design Group; and Noah Jeppson.

INTRODUCTION

Dallas's Dealey Plaza is a place with many historical facets. Considered "The Front Door of Dallas," the park rests on a bluff near the Trinity River, where a natural low-water crossing was identified in 1841 by Dallas's founder, John Neely Bryan. The crossing was already known to the American Indian tribes of the area, which included Anadarkos, a Caddoan group, and displaced Cherokees, Tonkawas, and Delawares.

The ford was the site of Bryan's cabin and the location of the first ferry and bridge over the Trinity River. Home to several Dallas County buildings and other historic structures, Dealey is not only the birthplace of Dallas. It is also the site of Dallas's first large-scale city planning solution: a traffic-diverting triple underpass and a beautiful downtown park built in the 1930s. The park was lodged into the national consciousness when Pres. John F. Kennedy was assassinated there on November 22, 1963. Today, the site is visited by over two million visitors annually. To preserve Dealey Plaza and its surrounding buildings, the federal government designated it a National Historic Landmark District in 1993.

Just weeks before his death, Kennedy delivered a speech in honor of the poet Robert Frost at Amherst College. In that speech, the president commented on the role of the arts and history in American society. After enumerating potential artistic prospects for the country, he noted the importance of historic preservation. "I look forward to an America . . . which will preserve the great old American houses and squares and parks of our national past." It is our hope that this book in some small way helps to realize Kennedy's goal.

One

BEFORE DEALEY PLAZA

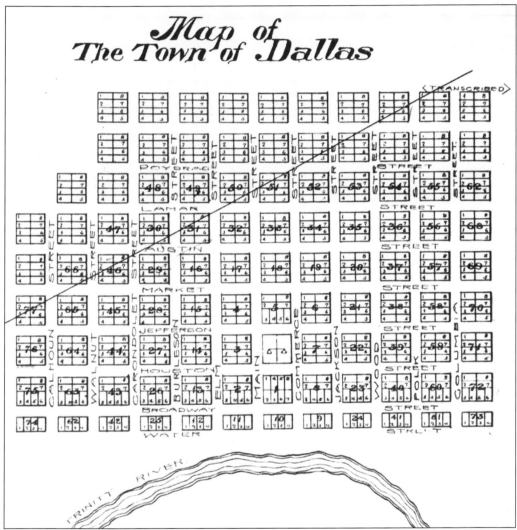

John Neely Bryan (1810–1874), founder of Dallas, was the first Anglo American settler in the Dallas area. He constructed a simple structure at the forks of the Trinity River in November 1841 on the east side of a natural ford, which was at the intersection of two existing American Indian traces. In 1844, he persuaded J.P. Dumas to survey and plat the townsite of Dallas. When the city was selected as the county seat, Bryan donated land for the courthouse and 90 town lots. This 1850 map is the earliest extant map showing the future Dealey Plaza area. (Dallas Municipal Archives.)

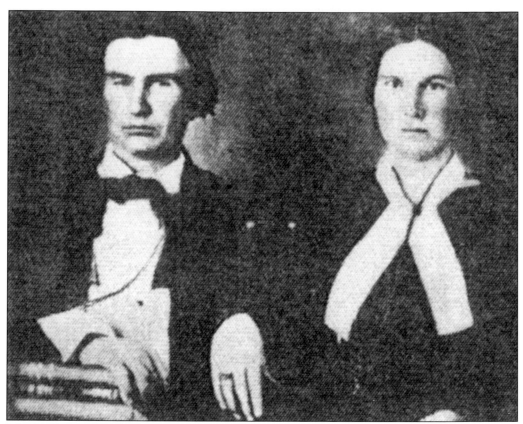

John Neely Bryan's cabin was built of cedar logs on the east bank of the river, near what is now Elm Street in Dealey Plaza. Except for interaction with American Indians, he lived alone for about a year. He married Margaret Beeman, daughter of one of the first families to settle in the area. The couple is shown in the above photograph. John Neely Bryan Jr. later recalled: "He pitched a crop of corn where the courthouse now stands. He made a plow of pieces of bois d'arc timbers spliced together, cut strips of buffalo hide for harness, and made [his horse] pull the plow." Buffalo and other wild game were plentiful in the area. Below is a reconstruction of the Bryan cabin, which has sat near the Dallas County Courthouse since the mid-1930s. (Both, Dallas Municipal Archives.)

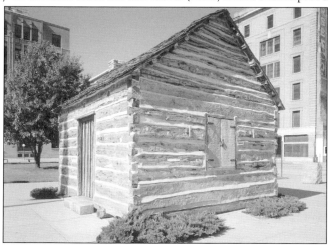

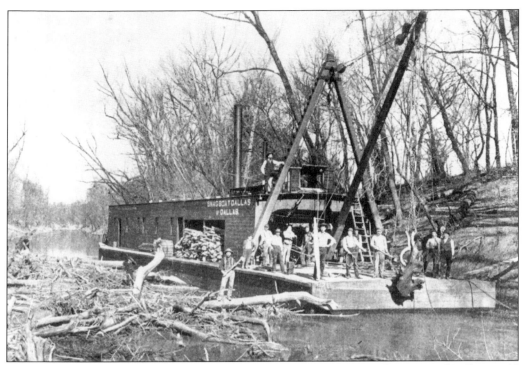

The area of the future Dealey Plaza was defined by the Trinity River. Early citizens of Dallas would have seen forestation up to the riverbanks. When navigation on the Trinity became a reality, snag boats, which cleared the waterways of driftwood, became a common sight. Above, a snag boat is at work in 1893. The photograph below shows the first passenger steamboat to arrive at the Commerce Street landing in 1893. (Both, Dallas Municipal Archives.)

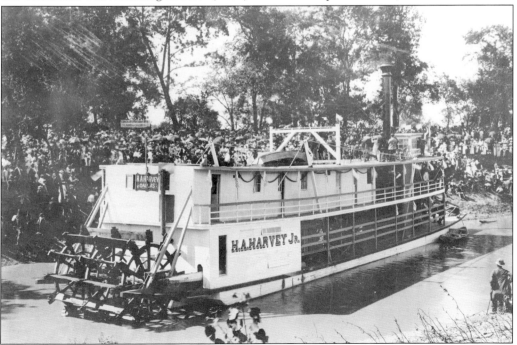

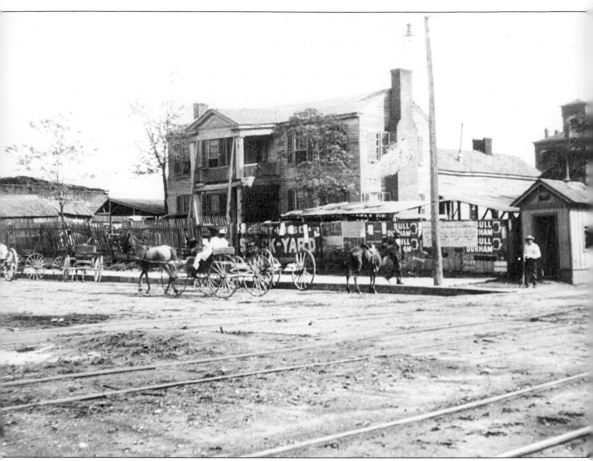

Sarah Horton Cockrell (1819–1892) was one of the most important figures in the history of Dallas and the Dealey Plaza area. An entrepreneur in her own right, she managed the businesses of her husband before and after his death in 1858 and enlarged her land and family enterprises. Among her Dealey-area achievements were the Cockrell Hotel, on Houston Street between Main and Commerce Streets; an iron suspension bridge across the Trinity River; the Todd flour mills; office buildings; and real estate. This is Sarah Cockrell's home, on the southeast corner of Broadway and Commerce Streets about 1890. The present Post Office Annex was built on this site after the Cockrell home was demolished in 1911. (*Dallas Morning News.*)

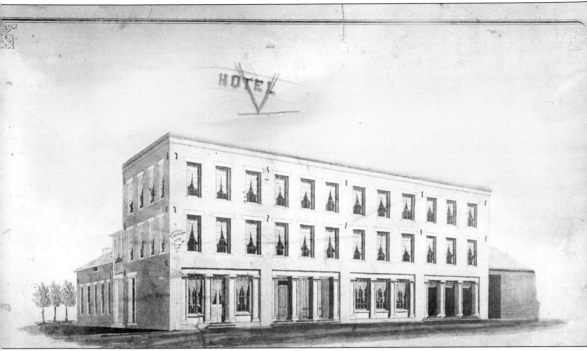

This is the first Cockrell Hotel, which burned down in the devastating central business district fire of 1860. The blaze wiped out most of the downtown area. A second hotel (later known as the Dallas and the St. Charles) was leveled in 1966 to make way for the John F. Kennedy Memorial Plaza. (*Dallas Morning News.*)

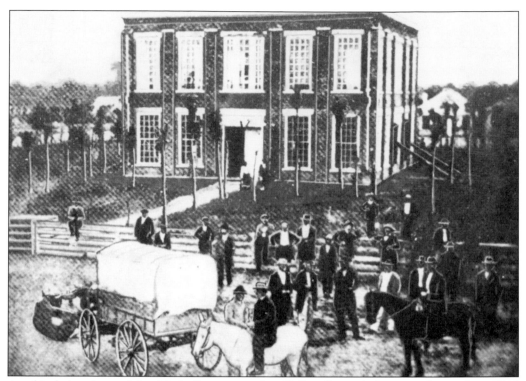

A cabin belonging to John Neely Bryan served as Dallas County's first courthouse from 1846 to 1848. It sat on the northeast corner of the courthouse square to avoid damaging Bryan's corn field. After it burned down, the first "permanent" courthouse, a dogtrot cabin, was built in 1850. This was replaced by a brick, two-story building in 1857. The 1857 courthouse, pictured above, escaped the devastating July 1860 Dallas fire and was replaced in 1871 by a stone building with a bell tower. That building, shown in the image below, burned down in 1880. (Above, *Dallas Morning News*; below, Dallas Municipal Archives.)

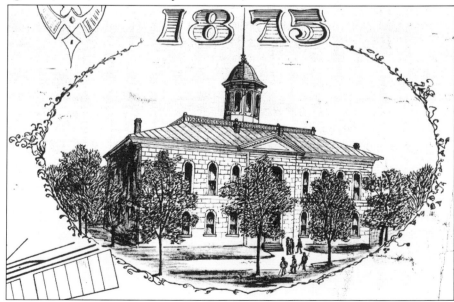

The 1882 courthouse, shown here, was in use for just 10 years before the 1892 courthouse was built. The 1892 courthouse is still standing and is known as "Old Red." (Dallas Municipal Archives.)

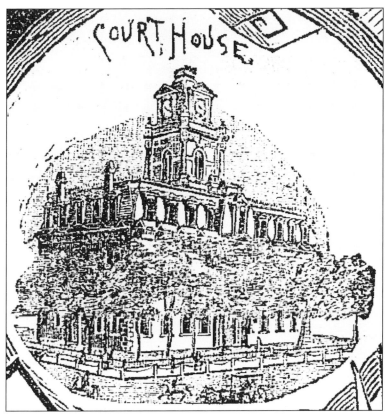

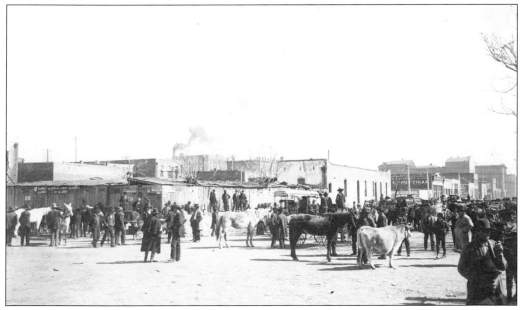

Wagon yards, livery stables, and livestock pens were a common sight in the Dealey Plaza area from the 1850s through the 1890s. Just past the courthouse to the south, looking east at Jackson Street from Houston Street, one might have seen the monthly stray livestock sales taking place, like this one from about 1893. (*Dallas Morning News.*)

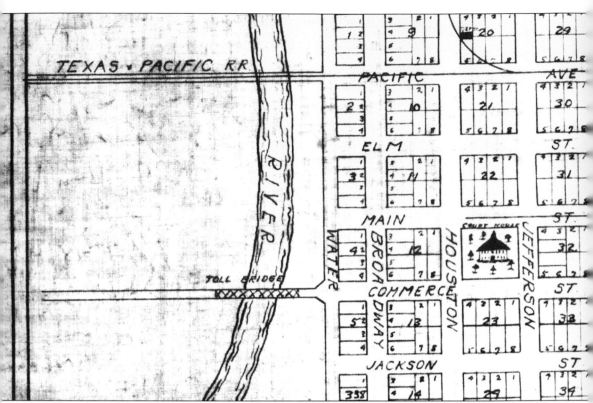

Before the rerouting of the river in 1928, there were two more streets parallel and west of Houston Street before the Trinity. This 1882 map shows Broadway, an unpaved road that provided a path for both commercial and passenger railroad tracks. The same tracks followed Pacific Avenue to the backside loading docks facing Elm Street. Water Street was a dirt footpath fronting the river. (Dallas Municipal Archives.)

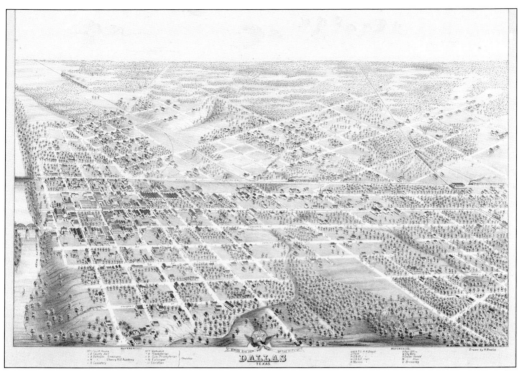

In 1872, Herman Brosius created a bird's-eye view of Dallas that is amazingly accurate in details. Above is the entire lithograph. Below is an enlarged detail of what is now Dealey Plaza. The courthouse square is in the center, and the Todd Flouring Mills face Broadway to the north of Sarah Cockrell's iron bridge. (Both, Library of Congress.)

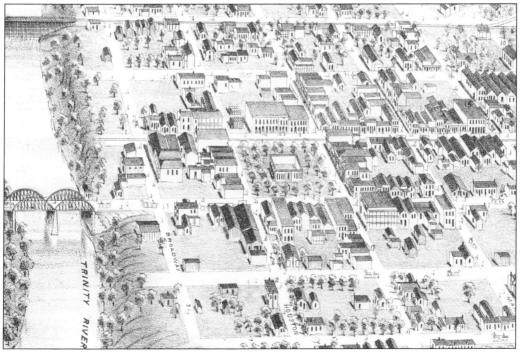

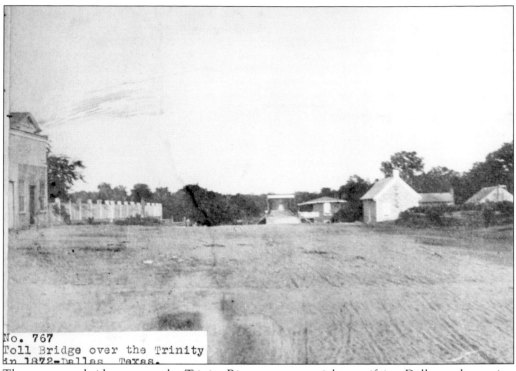

No. 767
Toll Bridge over the Trinity
in 1872-Dallas Texas.

Then, as now, bridges across the Trinity River were essential to unifying Dallas and ensuring the flow of people and goods. The first bridge to span the Trinity, a wooden covered toll bridge, was built in 1855 by Alexander Cockrell and extended from Commerce Street. The second Commerce Street Bridge was built in 1871. The bridge, shown above in 1872, was an iron bowstring toll bridge operated by Cockrell's widow until it was purchased by Dallas County in 1882. The building on the left is the Crutchfield House hotel; immediately to the right of the bridge is its tollbooth. The photograph below is a closer view of the same bridge, three years later. (Both, *Dallas Morning News.*)

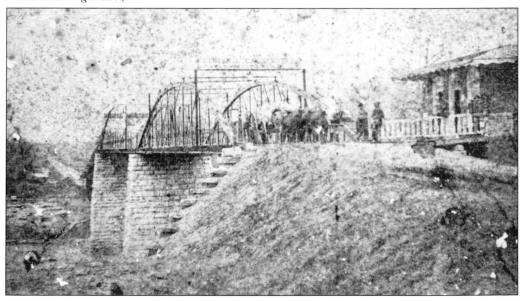

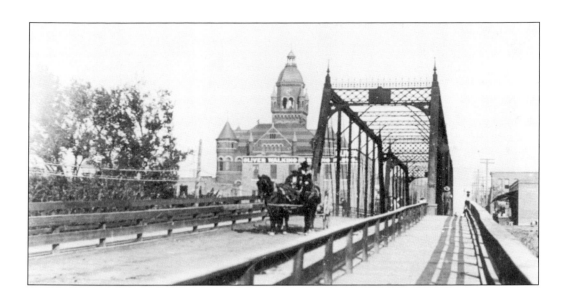

The 1889 iron bridge was still in use in this undated photograph taken from the west side of the bridge looking eastward. Old Red (the 1892 courthouse) looms in the distance. The fourth Commerce Street Bridge, shown below looking from the courthouse toward West Dallas, was built in 1916 but demolished to create the Commerce Street viaduct in 1932–1934 in conjunction with the future triple underpass. (Both, *Dallas Morning News*.)

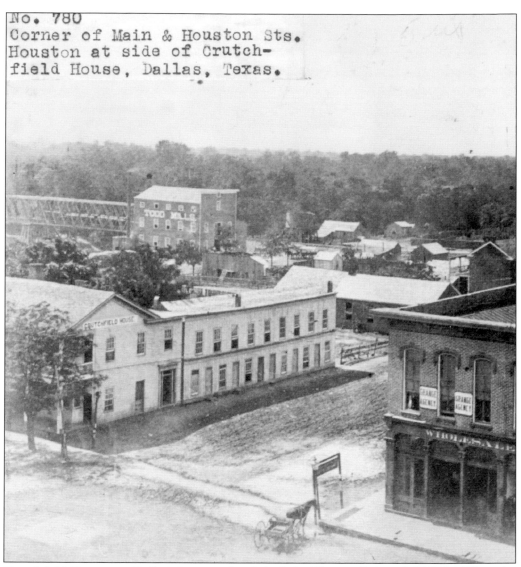

Crutchfield House was Dallas's first true hotel, built by Thomas F. Crutchfield in 1852 at the northwest corner of Main and Houston Streets. The original was destroyed in the great fire of 1860. It was rebuilt at Main and Broadway Streets as a plantation-style, two-story inn containing about 25 rooms. The inn hosted famous guests, from Sam Houston to John H. Reagan, and it had the first glass windows in Dallas. This building was destroyed by fire in 1888. This 1880 photograph of the hotel shows Todd Flouring Mills beside the Commerce Street Bridge. (*Dallas Morning News*.)

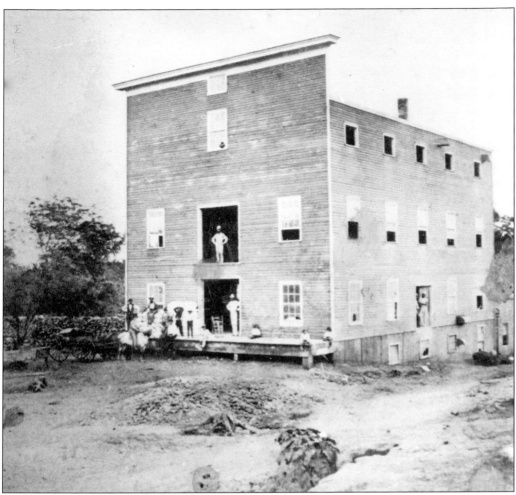

Flour milling, one of the first industries in Dallas, was centered originally in the Dealey Plaza area. The Todd Flouring Mills was Dallas's second commercial flour mill and another of Sarah Cockrell's business enterprises. (*Dallas Morning News.*)

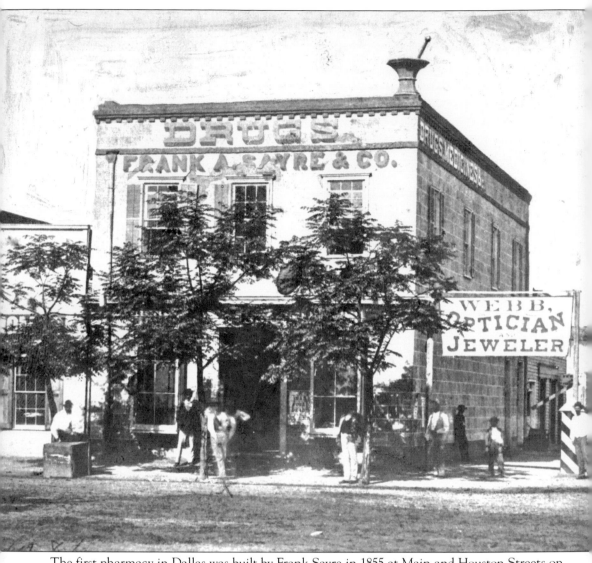

The first pharmacy in Dallas was built by Frank Sayre in 1855 at Main and Houston Streets on the west side of the courthouse square. After it burned down, the drugstore shown in this 1874 photograph was built on the same site. Sayre's son Sam purchased his future wife's engagement ring from the jeweler next door. (*Dallas Morning News.*)

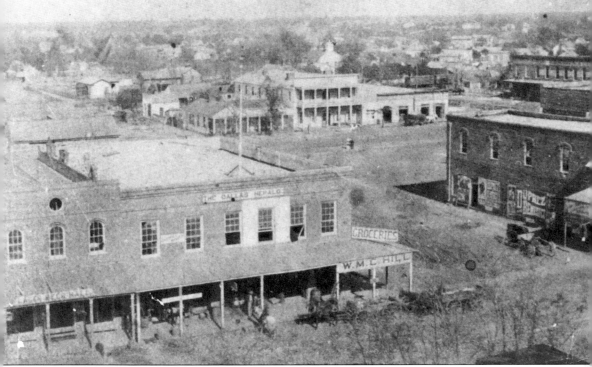

Not to be confused with the *Dallas Times-Herald*, the *Dallas Herald* was started by James Wellington "Weck" Latimer in 1849 and was the only game in town until the upstart *Dallas Morning News* purchased it in 1885. This 1874 photograph of the Herald building, taken from the top of the courthouse looking northeast, shows the lower end of Elm Street. (*Dallas Morning News.*)

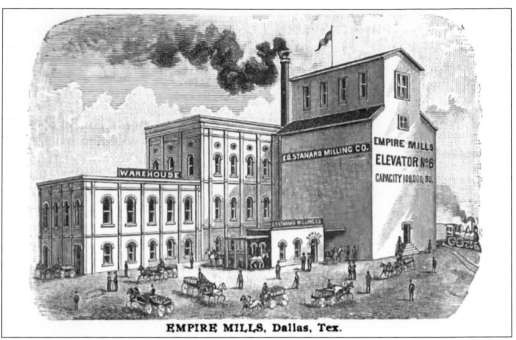

EMPIRE MILLS, Dallas, Tex.

Midwestern entrepreneur E.O. Stanard opened Empire Mills at the northeast corner of Elm and Houston Streets in 1885. Above, the Empire Mills is shown in an engraving from 1892. Below is a detail from a 1905 Sanborn Fire Insurance map showing the extent of the mill facilities. Milling operations in the area ceased about 1910–1913 and moved south after a new union terminal and an adjoining post office were planned for the area. (Above, New York Public Library; below, Texas State Library.)

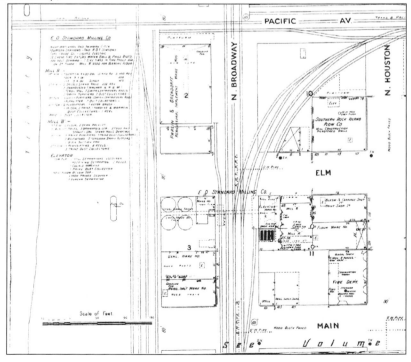

W. J. Lemp's Western Brewery

OFFICE AND BEER VAULTS:
Cor. Broadway and Main Streets.
DALLAS, TEXAS.

WESTERN BREWERY

W. J. LEMP'S
FIRST PRIZE
NATIONAL EXHIBITION
AWARDED BY
UNITED STATES
CENTENNIAL
COMMISSION
PHILADELPHIA MDCCCLXXVI
MEDAL
ST. LOUIS
LAGER BEER

ORDERS SOLICITED
And Beer Delivered Promptly to
All Parts of the City.

KEG AND BOTTLED BEER AND LAKE ICE
CONSTANTLY ON HAND.

TELEPHONE IN CONNECTION.

While the Dallas franchise of Lemp's Beer was brewed several blocks away, its warehouse and offices were located at the corner of Broadway and Main Street, as shown in this advertisement from 1905. (Texas/Dallas History and Archives Division, Dallas Public Library.)

Trains on Oak Cliff Elevated Railway

Will run as follows:

Leave St. George St. Station.	Leave Court-House.
6:35 a. m.	6:20 a. m.
7:30 a. m.	7:00 a. m.
8:20 a. m.	8:00 a. m.
9:30 a. m.	9:00 a. m.
10:30 a. m.	10:00 a. m.
11:30 a. m.	11:00 a. m.
12:20 p. m.	12:00 m.
1:30 p. m.	1:00 p. m.
2:30 p. m.	2:00 p. m.
3:30 p. m.	3:00 p. m.
4:30 p. m.	4:00 p. m.
5:30 p. m.	5:00 p. m.
6:30 p. m.	6:10 p. m.

Will stop at First, Third, Fifth, Eighth and Tenth street Stations. Trains will run until 11 p. m. on special occasions. Fare 10 cents; to residents of Oak Cliff, 5 cents.

Oak Cliff founder and entrepreneur T.L. Marsalis developed the Oak Cliff Elevated Railway to provide mass transit across the Trinity River. Service commenced in 1887 on 11 miles of track with 15 cars and four steam engines. After it changed hands, the railway converted to electric power. As this schedule from an 1887 edition of the *Dallas Morning News* shows, the trolley stopped directly in front of the courthouse on Houston Street. (*Dallas Morning News*.)

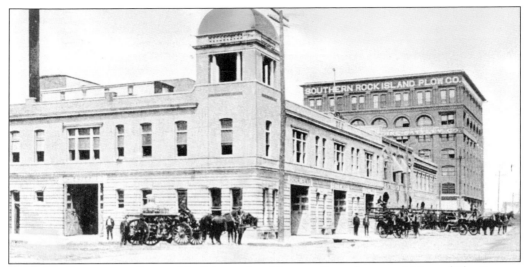

Dallas Fire Department Station No. 5, located on Houston Street between Main and Elm Streets, was built in 1890 and was a model station for the city's growing department. The two-story masonry building, with its corner tower, shared the block with the Dallas headquarters of the Dr. Pepper Bottling Company. The station is seen here about 1905. (*Dallas Morning News.*)

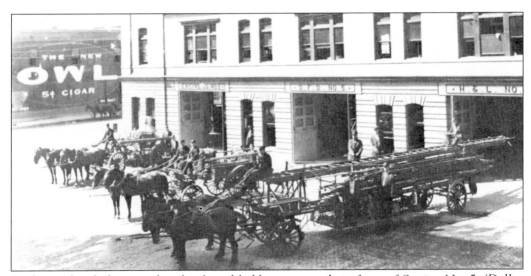

In this undated photograph, a hook and ladder cart stands in front of Station No. 5. (Dallas Firefighters Museum.)

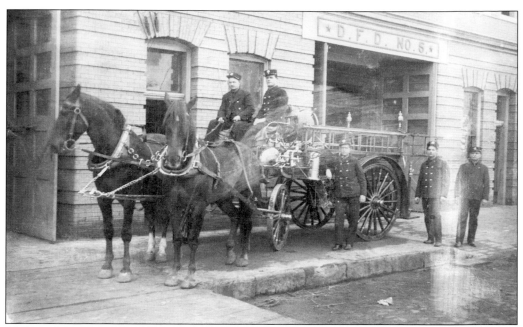

Above is another undated photograph of Station No. 5 with hook and ladder apparatus. Having outgrown it by the early 1920s, the city sold the building to the Fishburn Motor Company, which renovated the structure in 1925 (below). The building, along with the rest of the block, was razed in 1934 to make way for the triple underpass and Dealey Plaza. (Above, Dallas Firefighters Museum; below, *Dallas Morning News*.)

Our New Home

The New Ford Car
will be shown shortly in our new location at the foot of Main Street

We extend a cordial invitation to the people of this community to visit us. We believe that you'll admire our new home as well as the eagerly awaited new Ford models.

The New Home of Fishburn Motor Company at the Foot of Main Street.

Fishburn Motor Co.
Authorized Ford Dealer
FOOT OF MAIN STREET

GRIFFITHS & COWSER,

DEALERS IN ROUGH AND DRESSED

LUMBER.

Sash · · Doors ·

LINDS, MOULDINGS, &c.
LIME AND CEMENT.

Among the many types of business found in the Dealey Plaza area were lumberyards. Located a few blocks away, this yard was typical for the time. Griffiths & Cowser sold not only lumber, but doors, sashes, and other construction essentials. The founder's son, Tom Griffiths, became an early Highland Park civic leader and built the family business into a lucrative enterprise.

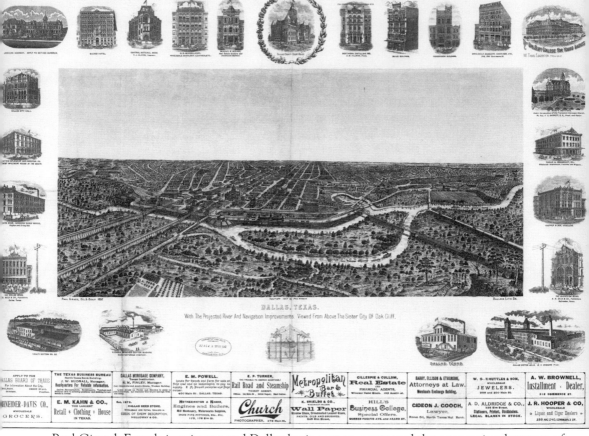

Paul Giraud, French immigrant and Dallas businessman, promoted the economic advantage of the growing city through this 1892 lithograph, entitled *Dallas, Texas. With the Projected River and Navigation Improvements Viewed from Above the Sister City of Oak Cliff.* (Library of Congress.)

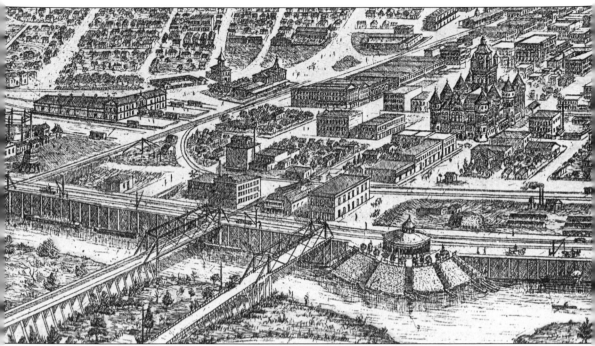

An enlargement of Giraud's lithograph shows the area that is now Dealey Plaza. While there are some accurate depictions, such as the new courthouse, the Trinity River's retaining wall and docks and the Jackson Street bridge are wishful embellishments that never materialized. (Library of Congress.)

NO. 61. N. Y. SPECIAL.

Don't fail to see our work before buying a New Buggy.

PARLIN & ORENDORFF CO.

145-147 ELM ST., DALLAS, TEXAS.

P & O

1842 1912

70 YEARS OF KNOWING HOW

BACKED BY AN UNQUALIFIED GUARANTEE.

WATERLOO BOY Gasoline Engine

THE PRICE IS 25% LOWER
THAN OTHER HIGH GRADE ENGINES

GUARANTEED FOR FIVE YEARS
Sold on Thirty Days' FREE TRIAL

Satisfactory Terms Given

WRITE FOR CATALOG

PARLIN & ORENDORFF IMPLEMENT CO.
General Agents Dallas, Texas

From the 1870s to the 1930s, farming implement companies were found throughout the Dealey Plaza area. Parlin & Orendorff, an important implement company, was headquartered in Illinois. Its Dallas franchise and warehouse were located at Broadway and Elm Street. Above is a buggy advertisement from the 1890s. At left, a newspaper advertisement for motors signals changing times. (Above, Dallas Firefighters Museum; left, *Dallas Morning News*.)

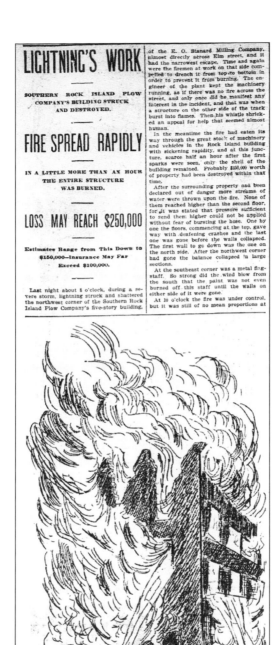

LIGHTNING'S WORK

SOUTHERN ROCK ISLAND PLOW
COMPANY'S BUILDING STRUCK
AND DESTROYED.

FIRE SPREAD RAPIDLY

IN A LITTLE MORE THAN AN HOUR
THE ENTIRE STRUCTURE
WAS BURNED.

LOSS MAY REACH $250,000

Estimates Range from This Down to
$150,000—Insurance May Far
Exceed $100,000.

Last night about 8 o'clock, during a severe storm, lightning struck and shattered the northwest corner of the Southern Rock Island Plow Company's five-story building, of the E. O. Stanard Milling Company, almost directly across Elm street, and it had the narrowest escape. Time and again were the firemen at work on that side compelled to drench it from top to bottom in order to prevent it from burning. The engineer of the plant kept the machinery running, as if there was no fire across the street, and only once did he manifest any interest in the incident, and that was when a structure on the other side of the track burst into flames. Then his whistle shrieked an appeal for help that seemed almost human.

In the meantime the fire had eaten its way through the great stock of machinery and vehicles in the Rock Island building with sickening rapidity, and at this juncture, scarce half an hour after the first sparks were seen, only the shell of the building remained. Probably $250,000 worth of property had been destroyed within that time.

After the surrounding property had been declared out of danger more streams of water were thrown upon the fire. None of them reached higher than the second floor, for it was stated that pressure sufficient to send them higher could not be applied without fear of bursting the hose. One by one the floors, commencing at the top, gave way with deafening crashes and the last one was gone before the walls collapsed. The first wall to go down was the one on the north side. After the northwest corner had gone the balance collapsed in large sections.

At the southeast corner was a metal flagstaff. So strong did the wind blow from the south that the paint was not even burned off this staff until the walls on either side of it were gone.

At 10 o'clock the fire was under control, but it was still of no mean proportions at

The first Rock Island Plow Co. building in Dallas was a five-story structure with a basement. It was erected at Elm and Houston Streets five years after the company was organized in Dallas as the Southern Rock Island Plow Co. The building was struck by lightning on May 4, 1901, and was totally destroyed by the fire. Undeterred, temporary quarters were secured, goods ordered, and, on Monday morning, May 6, the company opened for business as usual. (*Dallas Morning News*.)

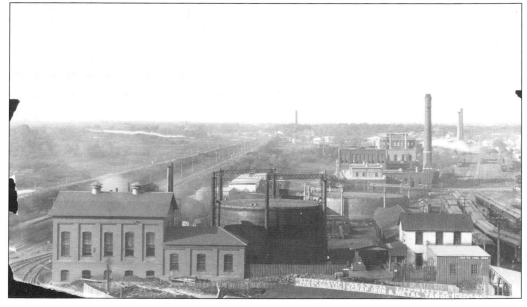

MAYER LIPSHITZ

Wholesale Dealer in

Metals, Scrap Iron, Rags
Machinery and Relaying Rails

Cotton, Cotton Wastes, Linters, Oat and Bran Sacks, Hides, Tallow, Press Cloth and Pecans

Local and Long Distance Phone in My Office, 3105. Western Union Code

MAIN OFFICE AND WAREHOUSE

Smelting and Refining Works
Chicago, Ill.

M. K. & T. Ry. and Houston St.,
DALLAS, TEXAS

Behind the Southern Rock Island Plow building were stone yards and scrap metal dealers. The advertisement above, for the Lipshitz Company, is from about 1905. The photograph below shows the yards as seen from the rooftop of the Rock Island building. (Above, Dallas Firefighters Museum; below, *Dallas Morning News*.)

Birds Eye View of a part of Dallas Implement & Saddlery Wholesale Houses. Dallas, Texas.

The Elm and Houston Street area became well known as a warehouse district for farming implement companies and saddleries. In this postcard view, the John Deere Plow Company (now the Dal-Tex building) is on the northeast corner of Elm and Houston Streets. Next to it is the Tension Brothers Saddlery Company, operated by the locally prominent Tenison family. On the opposite side of Elm Street are the structures that were eventually replaced by the Dallas County Records Building. (Jeff Dunn.)

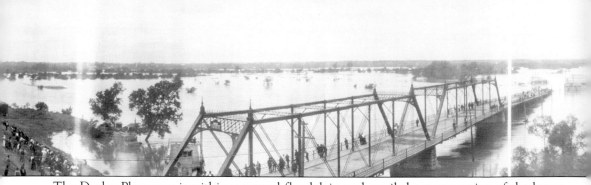

The Dealey Plaza area is within a natural floodplain and, until the construction of the levees from 1928 to 1932, was perpetually in danger of Trinity River flooding. Major floods, especially those in 1908 and 1935, were destructive. In this 1908 photograph, the Commerce Street Bridge is partly washed out, severing Oak Cliff and West Dallas from the eastern half of the city. Curious onlookers have gathered on the eastern side of the bridge. (Library of Congress.)

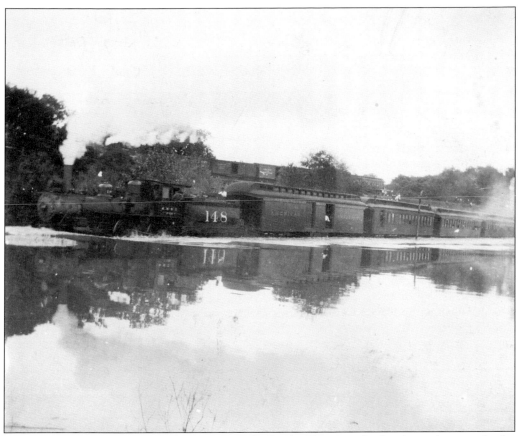

The 1908 flood was particularly devastating to the Dealey Plaza area. In the above photograph, the Missouri-Kansas-Texas tracks, which crossed the Trinity River a few blocks south, are barely above the waterline. Below, crowds wade through the muddy floodwaters at approximately Broadway and Elm Street. (Above, Dallas Municipal Archives; below, *Dallas Morning News*.)

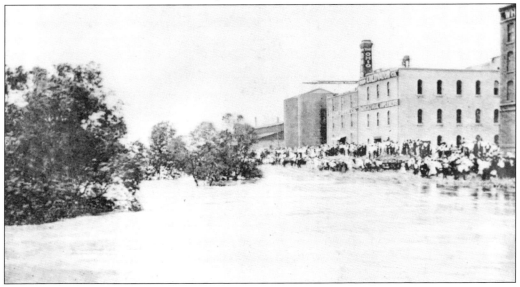

GEORGE E. KESSLER.
LANDSCAPE ARCHITECT.

In 1911, pioneering urban planner George Kessler suggested levees to control the Trinity River. Plagued by almost annual flooding, Dallas tamed the river through a series of levees, paid by the citizens of Dallas through a bond program passed in 1928. Kessler's planning interests extended to the east side of the river, where he recommended the placement of a Union train terminal and the consolidation of railway tracks in the central business district. All of these improvements, and the realignment of the river, enabled the future development of the triple underpass and Dealey Plaza. (Both, Dallas Municipal Archives.)

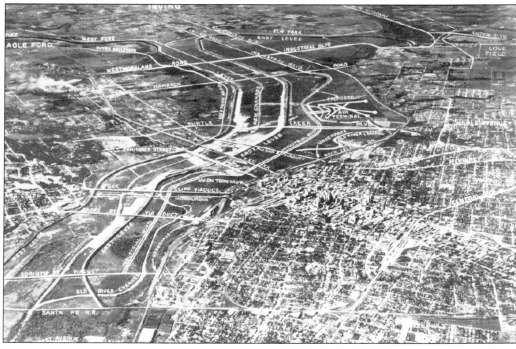

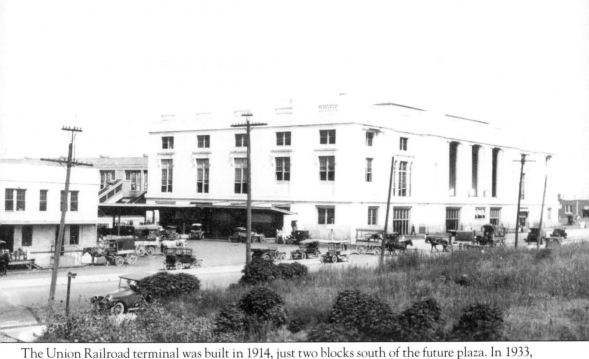

The Union Railroad terminal was built in 1914, just two blocks south of the future plaza. In 1933, an adjacent block was chosen for a permanent US Postal Service substation convenient to Union Station and capable of processing large volumes of mail. The site was across from the courthouse and adjacent to the eastern approach of the Commerce Street Bridge. In a few short years, it would become the southern boundary of Dealey Plaza. (Dallas Municipal Archives.)

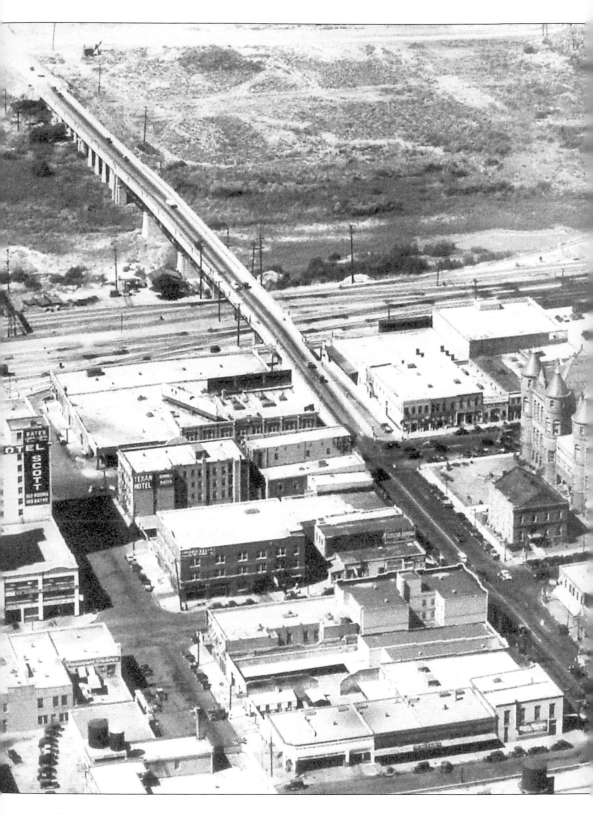

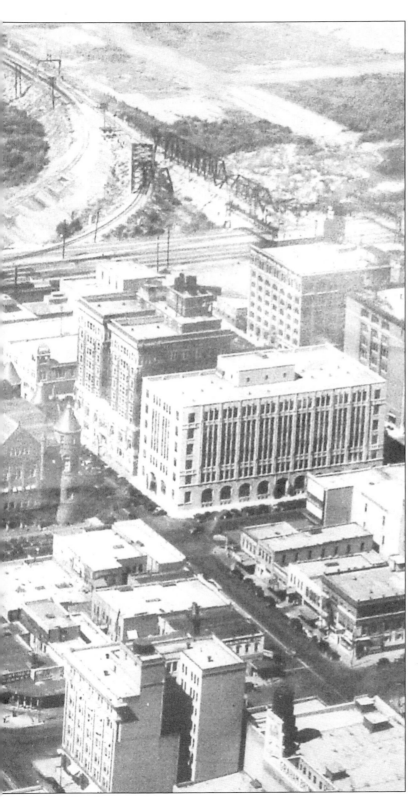

With the realignment of the Trinity River and the construction of a new system of bridges to span it, attention turned to the creation of a new western entrance to the city. Sights were set on two square blocks extending from Broadway to Houston Street and between Elm and Commerce Streets. This 1931 aerial photograph shows the blocks as they appeared about three years before the area was leveled. The river has been moved almost a quarter of a mile west. The 1916 Commerce Street Bridge is visible, as is the Texas & Pacific Railroad trestle bridge. (Dallas Municipal Archives.)

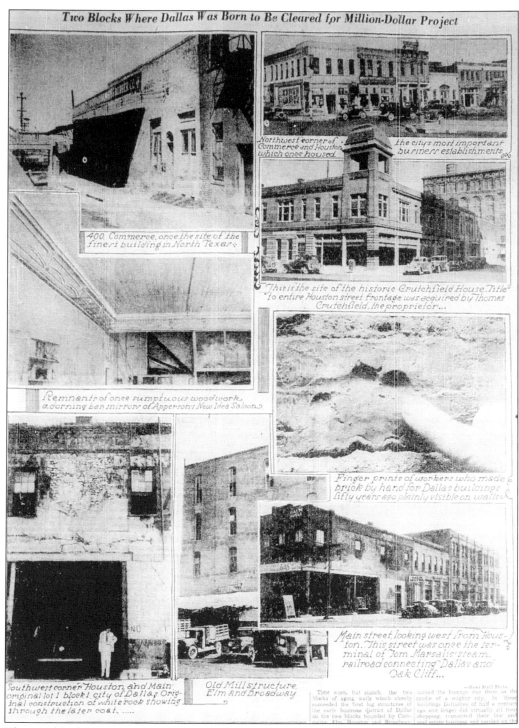

Two Blocks Where Dallas Was Born to Be Cleared for Million-Dollar Project

Northwest corner of Commerce and Houston which once housed

the city's most important business establishments

400 Commerce, once the site of the finest building in North Texas

This is the site of the historic Crutchfield House. Title to entire Houston street frontage was acquired by Thomas Crutchfield, the proprietor...

Remnants of once sumptuous woodwork, adorning bar mirrors of Apperson's New Idea Saloon

Finger prints of workers who made brick by hand for Dallas buildings fifty years ago plainly visible on walls

Main street looking west from Houston. This street was once the terminal of Tom Marsalis' steam railroad connecting Dallas and Oak Cliff...

Southwest corner Houston and Main, original lot 1 block 1 city of Dallas. Original construction of white rock showing through the later coat.

Old Mill structure Elm and Broadway

Time worn, but stanch, the two blocks of aging walls which closely succeeded the first log structures of the early business district of Dallas on the two blocks bounded by Commerce, Elm, Houston, and Broadway

accord the homage due them as the cradle of a mighty city. In these buildings Dallasites of half a century ago and longer did virtually all their shopping, transacted their law and real estate business and carried on ...

The two blocks slated for demolition contained some of the earliest buildings in Dallas. While the history of the area was acknowledged, the buildings themselves were considered ghosts of Dallas's past. In September 1934, on the eve of demolition, the *Dallas Morning News* profiled the historic buildings. (*Dallas Morning News*.)

Two

THE GATEWAY TO DALLAS

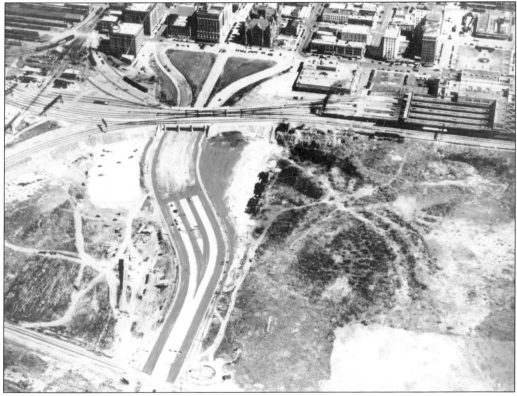

The ambitious public works project that would eventually be named Dealey Plaza required the reconfiguration of the three main streets in downtown Dallas into a six-lane boulevard on the western edge of the central business district. This 1936 aerial photograph illustrates how the three streets converged to pass under the railroad tracks that fed into Union Station, which can be seen in the upper right. West of the tracks, the new thoroughfare crossed the relocated channel of the Trinity River on the new Commerce Street viaduct and then continued west to Fort Worth. This massive undertaking was referred to as the "Elm-Main-Commerce underpass" or, more simply, the "triple underpass." (*Dallas Morning News.*)

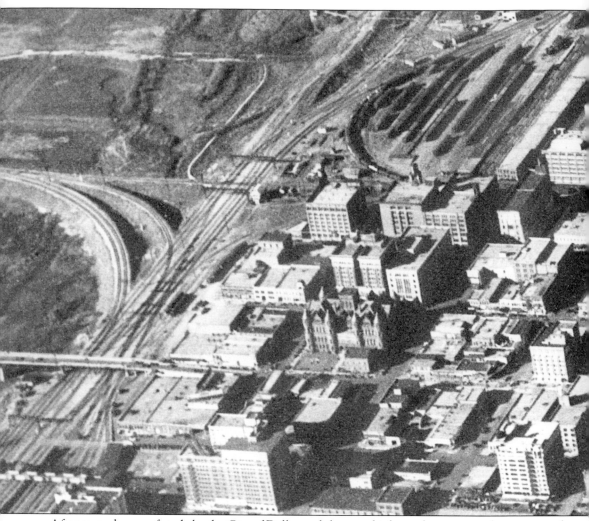

After several years of study by the City of Dallas and the state highway department, the concept of a triple underpass emerged as the most efficient means of redirecting Elm, Main, and Commerce Streets under existing railroad tracks to feed into Highway No. 1 and the Fort Worth Pike. This was a costly solution, however, as it required that the tracks be relocated approximately 125 feet to the west. When federal funding was made available to cover this expense, planning and land acquisition for the underpass moved forward. This 1933 aerial photograph shows the two blocks of buildings that would be demolished for the project. (Dallas Municipal Archives.)

Otto Lang Proposal for Approach to Triple Underpass

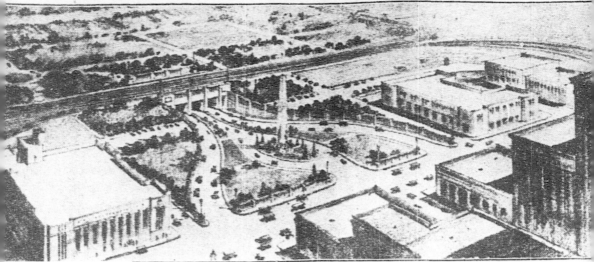

This is the Otto Lang sketch embodying his proposal for the approach and parking development incident to construction of the Commerce, Main and Elm underpass. Mr. Lang, a member of the City Plan Commission, advocates the acquisition of the two blocks between Houston, Elm, Broadway and Commerce to make possible gentle curves for the streets toward the underpass as well as adequate landscaping. His suggestion is enthusiastically indorsed by many Dallasites.

In November 1933, Dallas architect and city plan commission member Otto Lang presented his scheme, shown here, for the development of a heavily landscaped park as a vital component of the transportation project. Although the city had no funding for landscape improvements when the triple underpass was originally constructed, Lang's visionary proposal would eventually be implemented. (*Dallas Morning News.*)

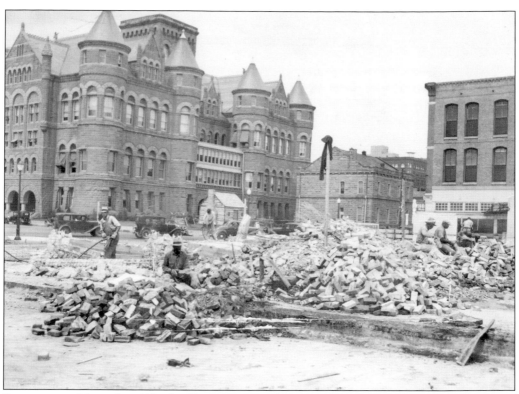

Beginning in November 1934, buildings were razed at a rapid pace to construct the Elm-Main-Commerce underpass. These two photographs demonstrate the amount of work that was done. (Above, *Dallas Morning News*; below, Dallas Public Library.)

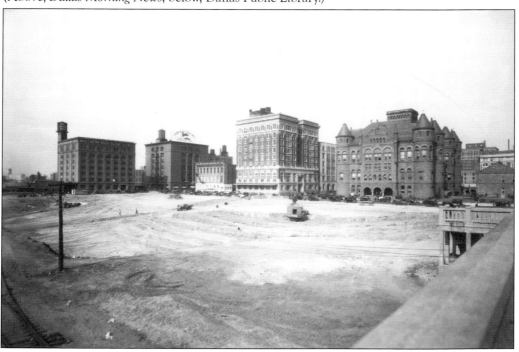

Huge Girders Being Placed for Triple Underpass

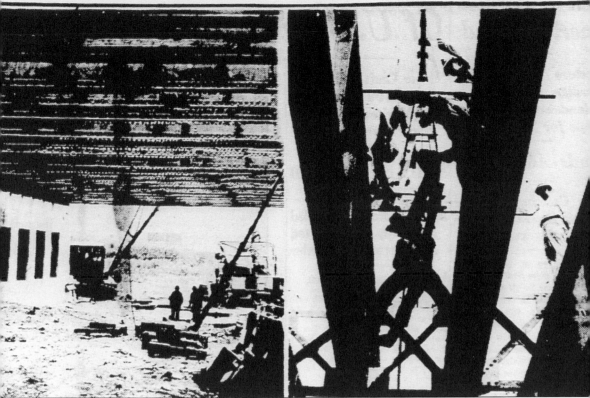

Excavation beneath existing train tracks was undertaken as the first step of construction. By June 1935, the massive concrete walls and overhead steel beams that would support new tracks were in place. A Texas & Pacific freight train was the first to pass over the bridge when it was completed five months later. (*Dallas Morning News.*)

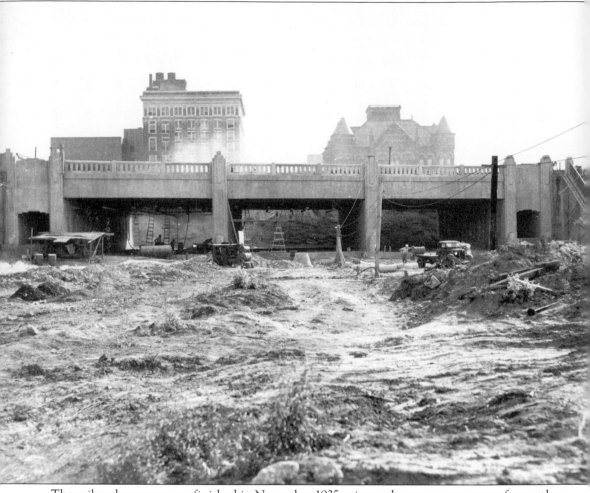

The railroad overpass was finished in November 1935 prior to the commencement of any other work at the site. In this photograph, looking west toward the bridge with downtown buildings beyond, solid earth can be seen on the far side of the three automobile tunnels. The *Dallas Morning News* commented that the modernist design of the underpass was "strikingly illustrated," reminiscent of the pylons and buildings at the 1933 Century of Progress Exposition in Chicago. (Dallas Public Library.)

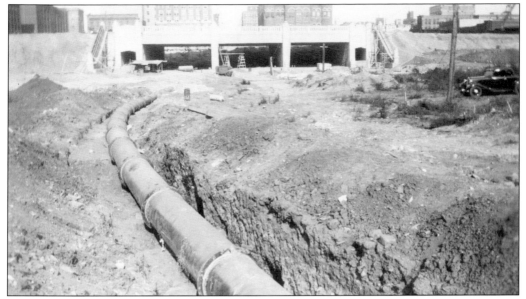

Following excavation and construction of the overpass, 65,000 cubic yards of earth were removed between the new bridge and Houston Street. Elm, Main, and Commerce Streets were regraded to slope down 24 feet. The convergence of these three streets under the bridge formed the triple underpass. The concrete paving process caught the interest of the *Dallas Morning News*. (Above, Dallas Municipal Archives; below, *Dallas Morning News*.)

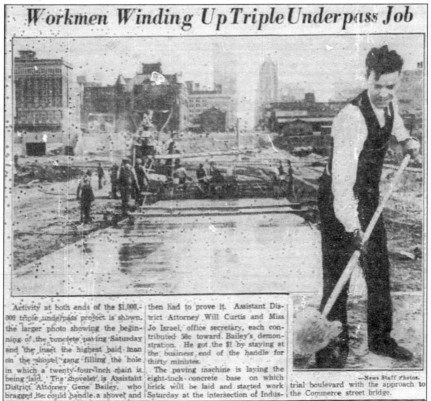

Workmen Winding Up Triple Underpass Job

Activity at both ends of the $1,000,000 triple underpass project is shown, the larger photo showing the beginning of the concrete paving Saturday and the inset the highest paid man on the "shovel" gang filling the hole in which a twenty-four-inch main is being laid. The shoveler is Assistant District Attorney Gene Bailey, who bragged he could handle a shovel and then had to prove it. Assistant District Attorney Will Curtis and Miss Jo Israel, office secretary, each contributed 50c toward Bailey's demonstration. He got the $1 by staying at the business end of the handle for thirty minutes.

The paving machine is laying the eight-inch concrete base on which brick will be laid and started work Saturday at the intersection of Industrial boulevard with the approach to the Commerce street bridge.

—News Staff Photos.

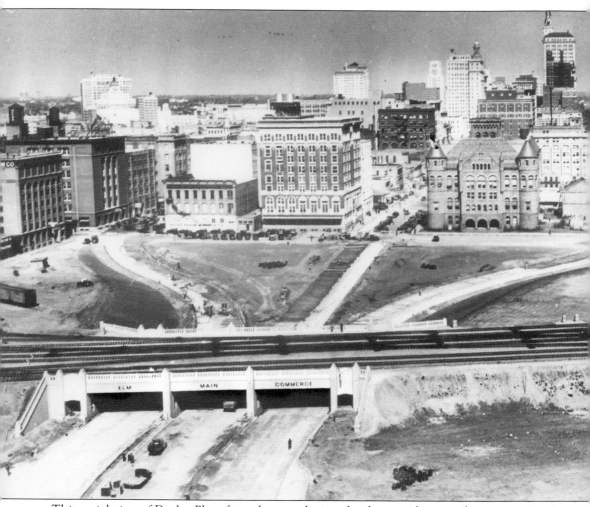

This aerial view of Dealey Plaza from the west depicts the three roadways under construction in early 1935. Signage for the streets—"Elm," "Main," and "Commerce"—can be seen on the west face of the triple underpass. Two prominent civic buildings on each side of Main Street presided over the plaza: the Dallas County Jail and Criminal Courts Building, in the center of the photograph, and, to the right, the turreted Dallas County Courthouse. (Dallas Public Library.)

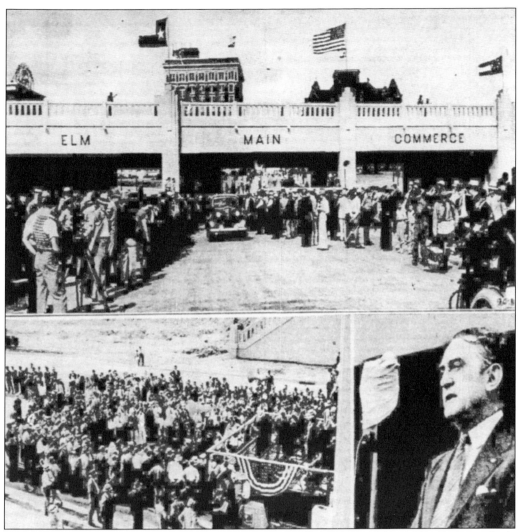

On May 1, 1936, Dallas celebrated the opening of the $1 million public works project, which served as the grand gateway to the central business district. Participants in the "stirring ceremonial pageant," as described in the *Dallas Morning News*, approached the underpass in two separate parades from the east and west. A speakers' platform, seen in the lower left view, was set up at the mouth of Main Street. The Dallas Police and Firemen's Band entertained the crowd prior to the dedication ceremonies, which were presided over by chairman Harry Hines, seen in the lower right image. The festivities concluded with a street dance and a square dance contest in the evening. This event served as a modest prelude to the opening of the Texas Centennial Exposition, which was kicked off the following week with a parade down Main Street witnessed by over 250,000 people. (*Dallas Morning News*.)

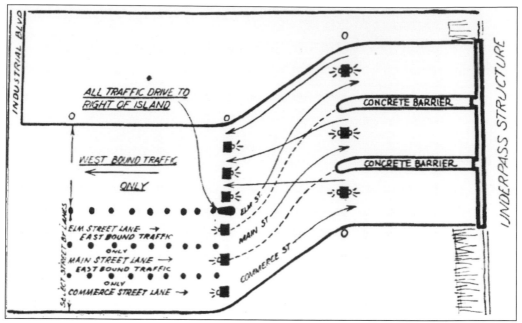

Controlling traffic on the western side of the triple underpass posed a significant problem for city engineers. Coming out of downtown, each of the three streets carried two-way traffic, which had to be sorted into a single six-lane roadway, as illustrated in this diagram. Timing of the signal lights was crucial, as westbound traffic on Main and Commerce Streets crossed incoming eastbound traffic on Elm and Main Streets. (*Dallas Morning News.*)

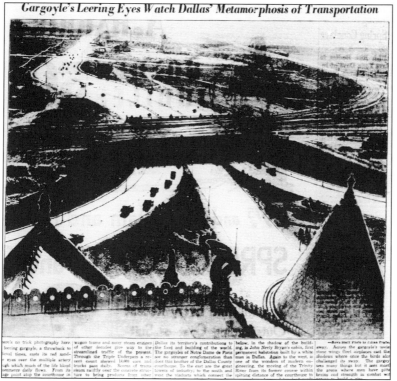

From its vantage point atop the Dallas County Courthouse, a gargoyle witnessed the progress of Dallas transportation, from plodding wagon teams in the 1890s to the streamlined thoroughfares of the 1930s. (*Dallas Morning News.*)

How Dealey Plaza Will Look in Future

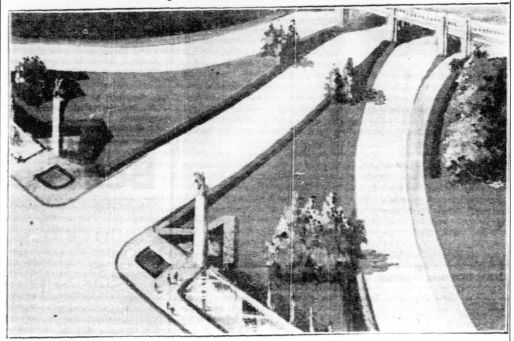

Work on a $15,000 beautification program for Dealey Plaza, east of the triple underpass, is scheduled to begin March 1, under a program to be carried out by the park department and the national youth administration.

A sketch of the development, prepared by George L. Dahl, is shown above. Sweeping lawns will lead from reflecting basins paralleling Houston street toward the underpass and all shrubbery will be low to retain visibility for drivers. Two twenty-five-foot columns and eight smaller ones will be constructed around the reflecting basins to carry out the monumental design.

C. P. Little is district superintendent of the NYA. Victor Jaeggli is district engineer, and A. L. Simpson, park board engineer. Members of the park board are Jim Dan Sullivan, president, Harry E. Gordon, George L. Chesnut, R. T. Shiels and Martin Weiss. The city and Federal Government will share the cost of the work.

Although the Dallas Park Board did not formally accept the land east of the triple underpass until September 1936, it announced that the site would be named Dealey Plaza a year earlier. A beautification program was initiated in conjunction with the National Youth Administration (NYA) in early 1937. Lyndon B. Johnson was the director of the NYA when Dallas's application for federal participation was submitted. Dallas architect George Dahl, known for his brilliant work at the Texas Centennial Exposition in 1936, prepared the design scheme for Dealey Plaza. His proposal featured reflecting pools and pylons along Houston Street. (*Dallas Morning News.*)

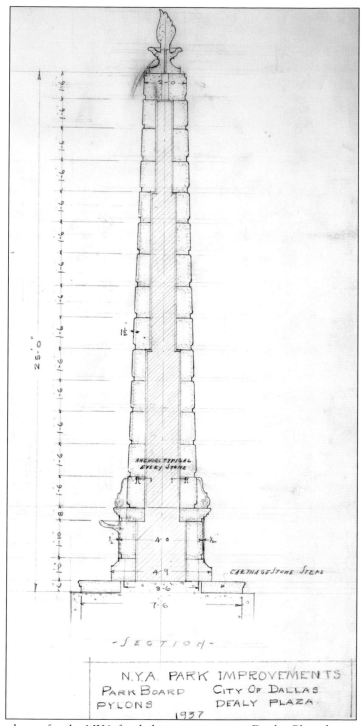

N.Y.A. PARK IMPROVEMENTS
PARK BOARD CITY OF DALLAS
PYLONS DEALY PLAZA
1937

George Dahl's scheme for the NYA-funded improvements at Dealey Plaza featured 25-foot-high stone pylons, or obelisks, that flanked the Main Street entrance into the park. One of these pylons remains today. The other, located at the southwest corner of Main and Houston Streets, was removed in 1949 and replaced with a statue of George B. Dealey. (Dallas Municipal Archives.)

54

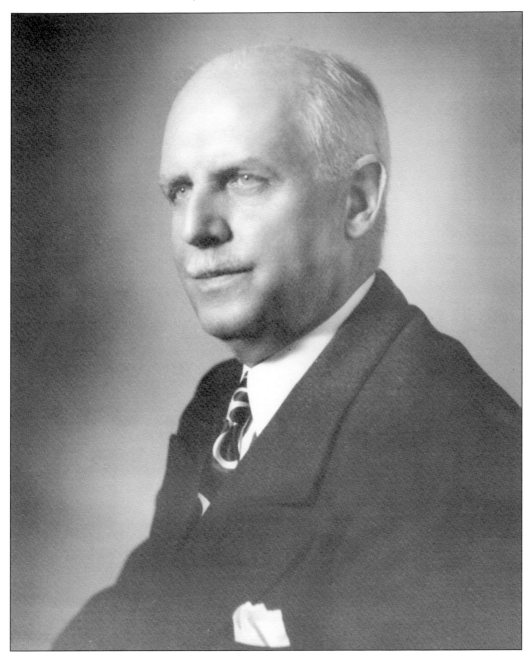

S. Herbert Hare was responsible for the design of the architectural elements and landscape of Dealey Plaza. He attended Harvard University, where he studied the emerging discipline of landscape planning under the tutelage of Frederick Law Olmsted. Hare returned to Kansas City in 1910 to join his father in founding Hare & Hare, one of the pioneering firms in America in the new profession of landscape architecture. By the 1920s, the firm's national reputation was well established. Herbert Hare was primarily involved with public-sector work for city planning and park commissions as well as for university clients throughout the United States. He was a principal consultant to the park board in Dallas, having completed numerous park master plans before and after the commission for Dealey Plaza. (Ochsner Hare & Hare.)

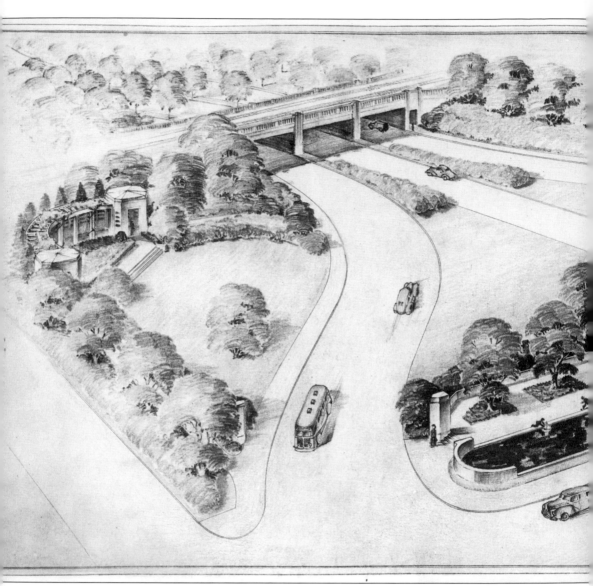

The physical character today of Dealey Plaza was largely determined by a second beautification program completed in 1941. The master plan was prepared by Hare & Hare, landscape architects from Kansas City. The main design features were twin concrete peristyles and plazas located behind the NYA-constructed reflecting pools and pylons along Houston Street and matching

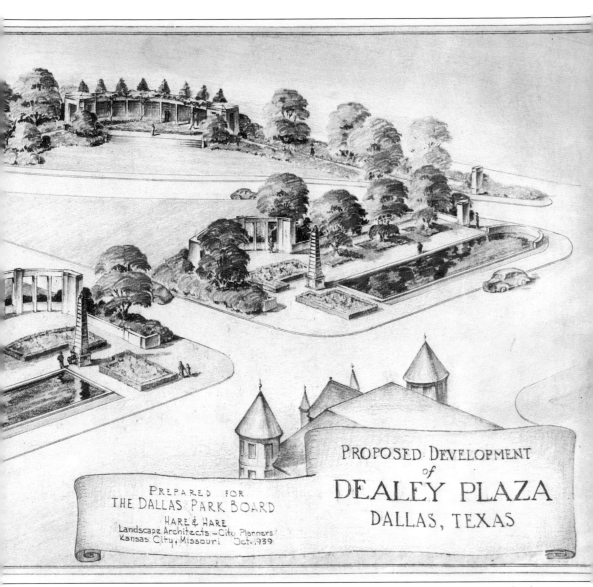

PROPOSED DEVELOPMENT
of
DEALEY PLAZA
DALLAS, TEXAS

PREPARED FOR
THE DALLAS PARK BOARD
HARE & HARE
Landscape Architects – City Planners
Kansas City, Missouri Oct. 1939

shelters and pergolas in the northwest and southwest corners of the site. This project was built by the Works Progress Administration (WPA) at a total cost of $92,298. Of this amount, $37,284 was contributed by the park board. (Dallas Municipal Archives.)

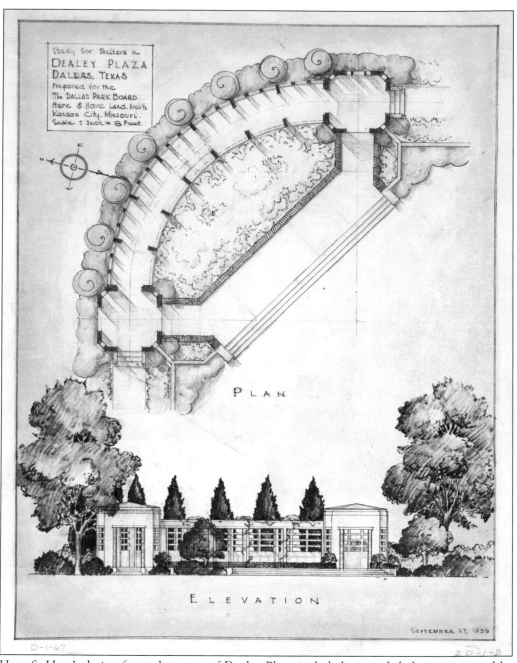

Study for Shelters in
DEALEY PLAZA
DALLAS, TEXAS
Prepared for the
The Dallas Park Board
Hare & Hare Land. Arch'ts
Kansas City, Missouri.
Scale 1 inch = 8 Feet.

PLAN

ELEVATION

SEPTEMBER 27, 1939

D-1-67

Hare & Hare's design for each corner of Dealey Plaza included covered shelters connected by a curving, open-air pergola. The modernist design of these structures complemented the Art Deco styling of the triple underpass. A diagonal plaza with steps leading down to the grass lawn connected each pair of shelters. These important features of Hare & Hare's design were restored to their original condition by the Dallas Park and Recreation Department in 2013. (Dallas Municipal Archives.)

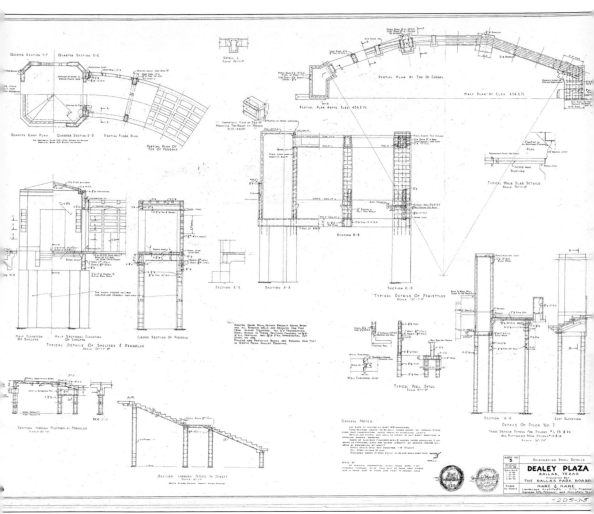

The construction drawings, prepared by Hare & Hare, were utilized by the WPA crews to build Dealey Plaza. This sheet consists of details to build the pergola located at the northwest corner of the site. Concrete piers provided structural stability under the various components of the pergola and nearby steps. (Dallas Municipal Archives.)

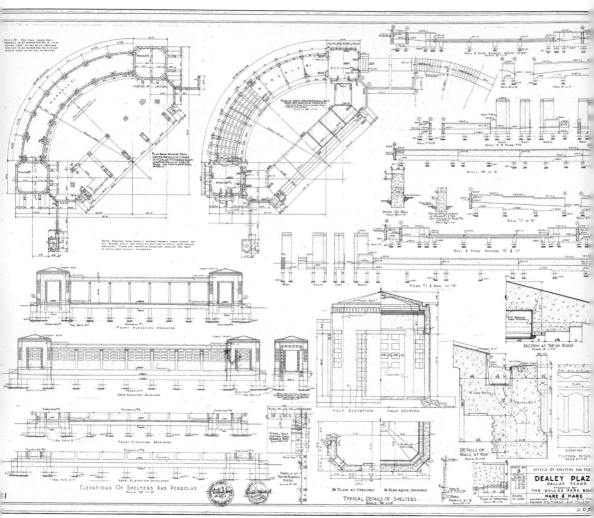

The drawings prepared by Hare & Hare for the shelters and pergolas (this page) and the peristyles and plazas (following page) illustrate the cast concrete construction and the spare Art Deco detailing of all the architectural elements at Dealey Plaza. The shelters and pergolas anchored the two west corners of the park. Copper roofing surmounted the twin shelters. (Dallas Municipal Archives.)

60

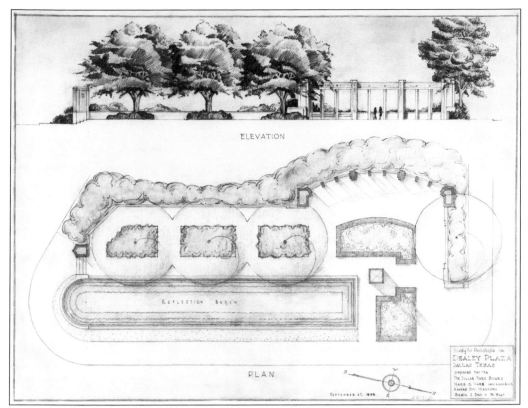

ELEVATION

PLAN

REFLECTION BASIN

SEPTEMBER 27, 1939

Along Houston Street, Hare & Hare designed new peristyles and paved plazas that had to incorporate the existing reflecting pools and pylons previously constructed by the NYA. The documents on this and the preceding page reflect the construction that occurred on the south side of the park. These drawings were also used by the WPA to build the other half of Dealey Plaza, on the north side of Main Street. (Both, Dallas Municipal Archives.)

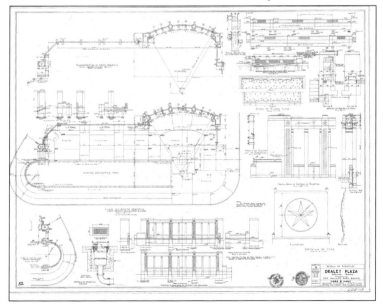

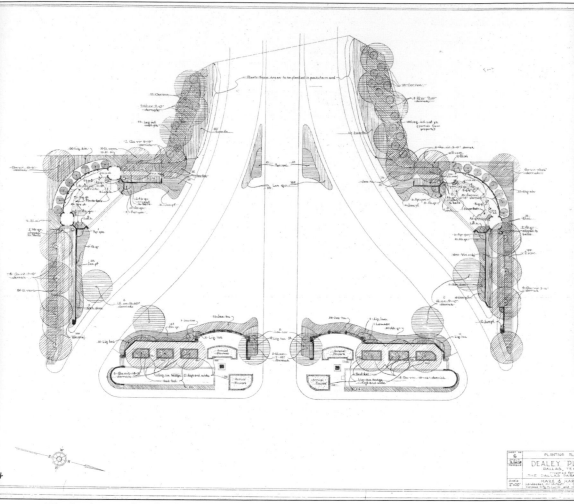

The landscape plan developed by Hare & Hare for Dealey Plaza featured shade trees (live oaks and cedar elms) around the perimeter of the site and ornamental trees (Texas redbud and Carolina cherry laurels) along Commerce and Elm Streets where they curved into the triple underpass. Evergreen trees (red cedars) served as a backdrop to the curving peristyles. Shrubs, vines, and ground covers were planted to accentuate the architectural elements. (Dallas Municipal Archives.)

Dealey Plaza Shelter House Starts Taking Form

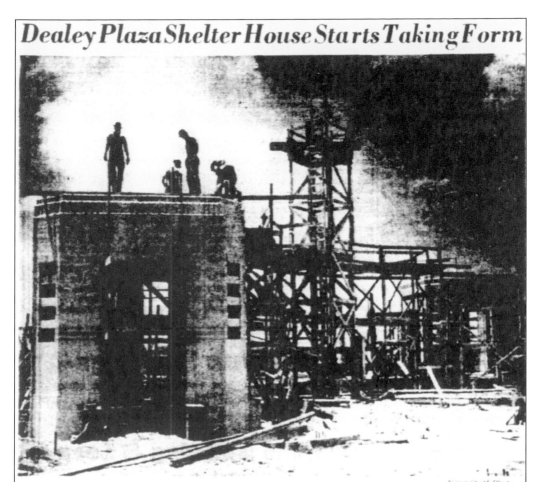

News Staff Photo

Beautification of Dealey Plaza, gateway through the Triple Underpass to the city from the west, has progressed so a substantial idea can be obtained of how the $92,298 city-WPA project is going to look. Work began March 10, is scheduled for completion about Nov. 1. This is one of the two curving shelter-house and pergola structures that will grace the corners nearest the tracks. Opposite them, on the courthouse side of the park, will be a pair of similarly curved structures called peristyles, one behind each of the two present reflecting basins. A complete landscaping program, costing $10,000, will involve a solid carpet of grass between the broad, curving sidewalks that will connect all points on the plaza, with a host of flower ornamentations and many cedar elms, red cedars and live oaks.

The WPA commenced work on Dealey Plaza in March 1940, completing the project 11 months later, in February 1941. In this photograph of the construction, taken in July 1940, concrete work on the two shelters is largely complete, and the WPA workers are beginning to erect the wood frame for construction of the curving pergola. (*Dallas Morning News*.)

FEDERAL WORKS AGENCY
WORK PROJECTS ADMINISTRATION

FILE
4945

PROJECT RECORD OF SPONSOR'S CONTRIBUTIONS

For the Project
Pay Roll Month from __12-24__ , 19 __40__ to __1-20__ , 19 __41__ W. P. No. __15280__ O. P. No. __65-1-66-386__ Type of Work Symbol __1330__ Program Class __101__

Sponsor __City of Dallas (Park Board)__ Expenditure Symbol __665008 (19)__ County Number __57__ District Number __4__

SECTION 1. - MONTHLY TIME REPORT FOR SPONSOR'S CONTRIBUTIONS - PAY ROLL

NAME AND CLASSIFICATION OF WORKER or EQUIPMENT OPERATOR	1st. Period 24 25 26 27 28 29 30 31 1 2 3 4 5 6	2nd. Period 7 8 9 10 11 12 13 14 15 16 17 18 19 20	TOTAL HOURS	RATE	AMOUNT
W.C.Markham (Carpenter)	8 8 9 8 8 8	6 8 8 9 8 11 8	157	Hr. .75	117 75
W.M.Emerson (Carpenter)	8 8 9 11 8 8	6 8 3 7 4 8	125	Hr. .62½	78 12
Roy Vinson (Truck Driver)	4 8 8	2	34	Hr. .37½	12 75
Homer Abney (Truck Driver)	8 8 8 8 8 2	2	44	Hr. .37½	16 50
~~Homer Dodd,~~ ~~Eufaalia (Truck Driver)~~				Hr. .37½	
J.E.Crawford (Truck Driver)				Hr. .37½	
TOTAL			360	X X X	225 12

SECTION 2. - MONTHLY TIME REPORT FOR SPONSOR'S CONTRIBUTIONS - EQUIPMENT

DESCRIPTION OF EQUIPMENT	1st. Period 24 25 26 27 28 29 30 31 1 2 3 4 5 6	2nd. Period 7 8 9 10 11 12 13 14 15 16 17 18 19 20	TOTAL TIME	RATE	AMOUNT
Dump Truck(Int'l 1932) spo.owned & Oprd 2½ Cy.Lic.X5-867 (Roy Vinson)	4 8	4 8 8 2	34	Hr. .95	32 30
Dump Truck (V-8,1936 spo.owned & Oprd 2½ Cy.Lic.X5-875 (Homer Abney)	8 8 8 8 8 2	2	44	Hr. .95	41 80
~~Dump Truck (V-8,1937 spo.owned & Oprd 2½ Cy.Lic.X5-900 (G.C.Adds)~~				Hr. .95	
~~Dump Truck (V-8,1939)spo.owned & Oprd 2½ Cy.Lic.X5-874 (J.E.Crawford)~~				Hr. .95	
Dump Truck (Dodge 1936 spo.owned WPA 2½ Cy.Lic.X5-896 Oprd	8 8 8 8 8 7 8 8 8 8	9 8 4 4	118	Hr. .80	94 40
Rig Saw,Portable Spo.owned Heavy duty gas #64285 Vis.Engine #3	4 3 4 8 4 2 2 4 4	8 8	72	P.P. 32.30	32 30
TOTAL			X X X	X X X	200 80

SECTION 3. - MONTHLY REPORT OF SPONSOR'S CONTRIBUTIONS - MISCELLANEOUS ITEMS (Other than Payrolls, Equipment, or Materials and Supplies)

DESCRIPTION (Give in detail)	UNIT	QUANTITY	PRICE	AMOUNT
TOTAL	X X X	X X X	X X X	

This payroll and equipment log for Dealey Plaza covered the period between December 24, 1940, and January 20, 1941. It documents the workers paid by the City of Dallas as the sponsor of the project. W.C. Markham, a carpenter, worked 157 hours during this period at a pay rate of 75¢ per hour. The four truck drivers on the payroll were paid half this amount, 37.5¢ per hour. Markham's total pay over these four weeks was $117.75. He worked on Saturdays and had a 15-hour day on January 10. (Dallas Municipal Archives.)

When G. B. Dealey was 15 years old he went to work for The News as office boy.

At the age of 19, Mr. Dealey was a clerk in the mailing room.

When The Dallas News was started, he became business manager of the new paper. He was 26 years old.

In 1896, 37 years old, he was made manager of the entire Dallas organization.

At the age of 50, Mr. Dealey had become vice-president and general manager of the Dallas-Galveston papers.

Just before his election as president of the A. H. Belo publications he passed the age of 60.

(Left) Publisher of The Dallas News and associated enterprises, at the age of 70 years, he walks to his office. On his eightieth birthday, Mr. Dealey was the recipient of good wishes from a host of friends.

The park board named Dealey Plaza on September 19, 1935, for George Bannerman Dealey (1859–1946), civic leader and longtime publisher of the *Dallas Morning News*. Under his guidance, the newspaper was perpetually involved in the cause of civic planning in Dallas. Dealey's efforts were instrumental in the adoption of a city plan that was prepared by the planner and landscape architect George E. Kessler in 1910. (*Dallas Morning News*.)

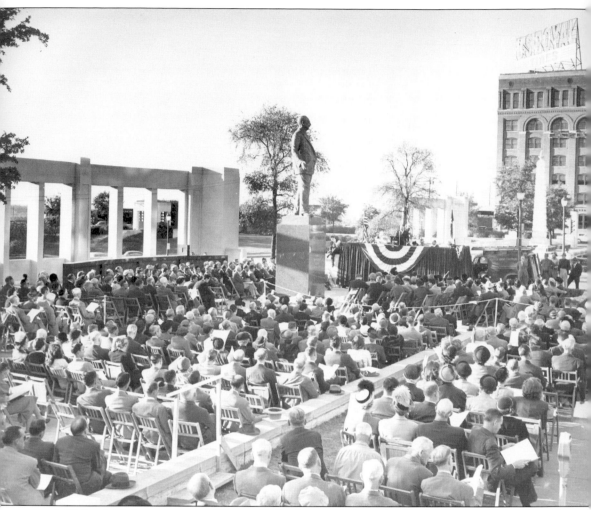

A 12-foot-high bronze statue of George B. Dealey was dedicated at Dealey Plaza on November 14, 1949, three years after the civic leader's death. Woodall Rodgers, chairman of the G.B. Dealey Memorial Association, presided over the ceremony, which was recorded for broadcast by both radio and television. The sculpture replaced one of the stone obelisks that had been built in this location by the NYA in 1937. The sculptor was Felix de Weldon (1907–2003), who would later design the USMC Iwo Jima Memorial in Roslyn, Virginia, in 1954. (Dallas Historical Society.)

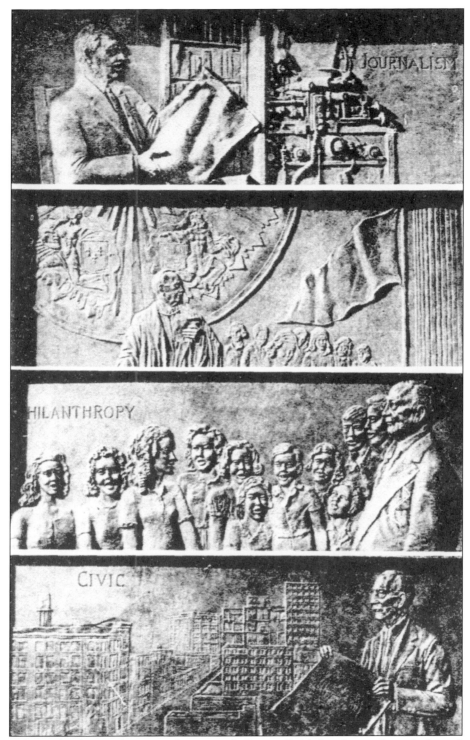

The sculptor also designed, in consultation with George Dahl, four bronze bas-relief panels that were installed behind the base of the sculpture. These four panels represented Dealey's main life interests: journalism, history, philanthropy, and civic enterprise. (*Dallas Morning News.*)

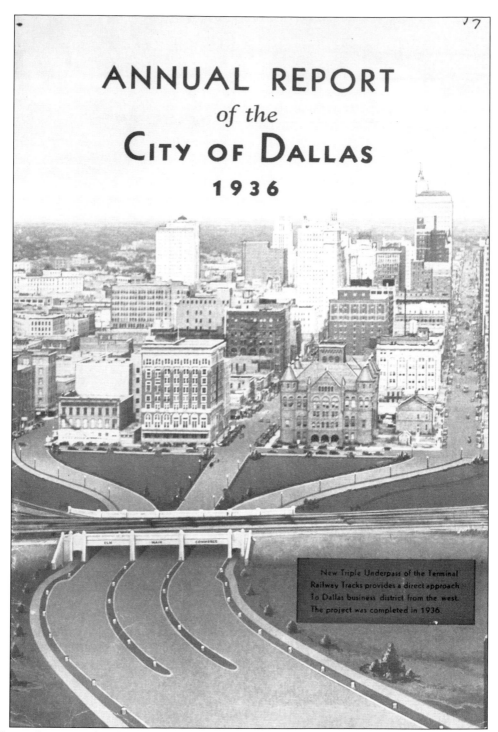

ANNUAL REPORT
of the
CITY OF DALLAS
1936

New Triple Underpass of the Terminal Railway Tracks provides a direct approach To Dallas business district from the west. The project was completed in 1936.

The underpass and park space were celebrated even before the project was completed. In this cover of the 1936 annual report of the City of Dallas, the streets have been airbrushed in and the plaza does not yet have the improvements later added by the NYA and the WPA. (Dallas Municipal Archives.)

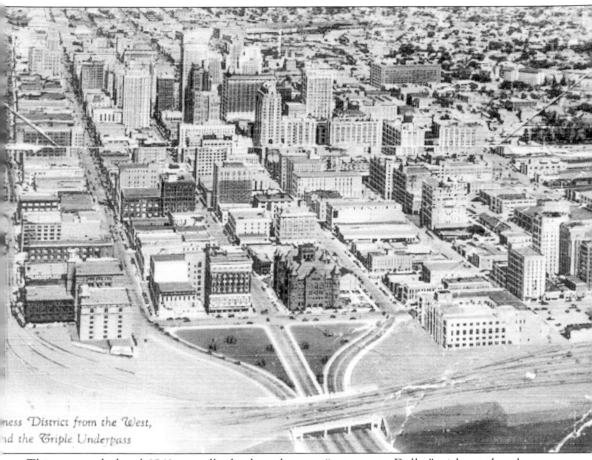

ness District from the West,
d the Triple Underpass

This postcard, dated 1941, proudly displays the new "gateway to Dallas" without the plaza improvements, despite the fact that they had been completed a year earlier. A close look reveals that the pergolas, peristyles, and fountains are missing. (Sally Rodriguez.)

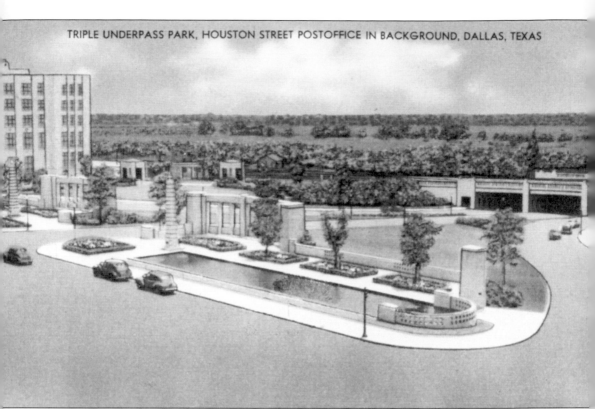

TRIPLE UNDERPASS PARK, HOUSTON STREET POSTOFFICE IN BACKGROUND, DALLAS, TEXAS

When the WPA completed construction of Dealey Plaza in 1941, Dallas gained an iconic image that would be featured on numerous postcards during the 1940s and 1950s. The new gateway to Dallas was not only an innovative transportation achievement, but also served as a beautifully landscaped parklike entrance to a vibrant and growing metropolis. (Dallas Municipal Archives.)

Three

THE BUILDINGS OF DEALEY PLAZA

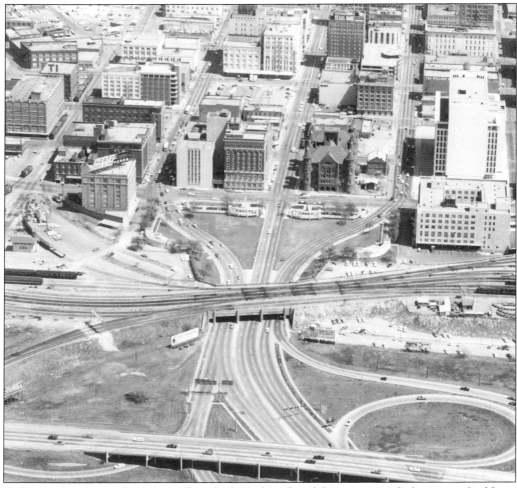

Today, Dealey Plaza and its surroundings look much as they did 70 years ago. Only two new buildings have been constructed during this time period: an expansion of the County Records Building (southeast corner of Elm and Houston Streets) in 1955 and the new County Courthouse and Jail (southeast corner of Commerce and Houston Streets) in 1965. Dealey Plaza is the centerpiece of two overlapping historic districts: the West End Historic District (1978) and the National Historic Landmark District (1993). (Dallas Municipal Archives.)

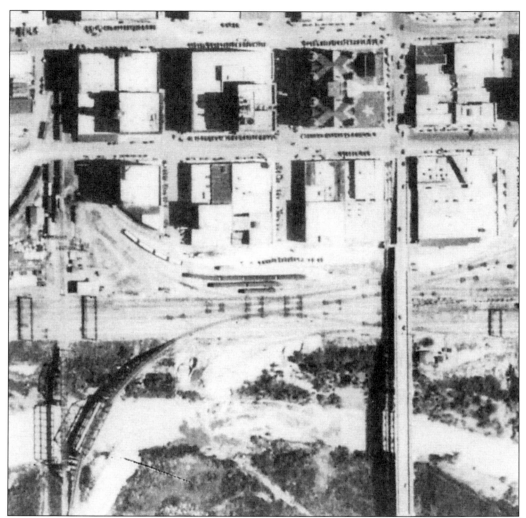

This 1930 view of the area surrounding Dealey Plaza can be compared with a similar view on the opposite page, taken in 2001. The two blocks of buildings that were purchased by the City of Dallas for construction of the triple underpass are in the center of this photograph, on the west side of Houston Street. Trains and tracks can be seen on the left as they fan out in three directions. On the lower right is the old Commerce Street viaduct, which would be demolished and rebuilt, extending one mile to the west to cross the relocated Trinity River. (Dallas Municipal Archives.)

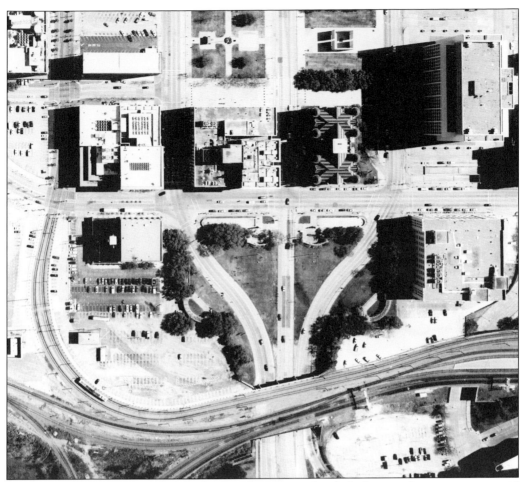

This contemporary image of Dealey Plaza can be compared with the historic downtown street grid evident in the aerial view on the opposite page. In order to achieve the gradient allowing Elm, Main, and Commerce Streets to pass under the railroad tracks that fed into Union Station, the original tracks had to be relocated approximately 125 feet to the west. (MESA Design Group.)

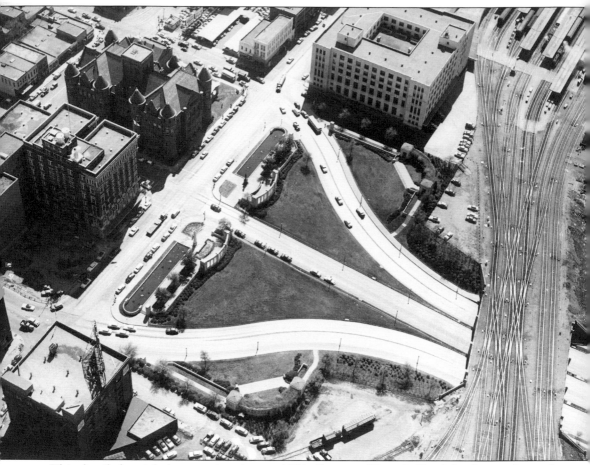

This detailed aerial photograph, taken in 1954, illustrates Hare & Hare's landscape design for Dealey Plaza. Fountain basins and peristyles parallel Houston Street on the plaza's east side. Matching pergolas anchor the northwest and southwest corners of the park. The Texas School Book Depository building is in the lower left of this image. (Dallas Municipal Archives.)

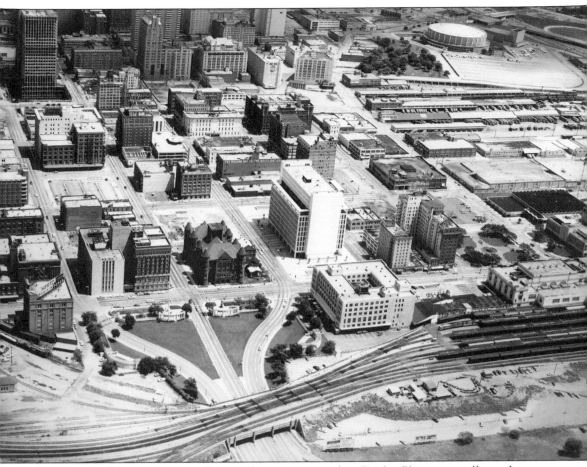

In 1967, many of the original buildings in the area surrounding Dealey Plaza were still standing. The significant newcomer was the 1965 county courts building, located across Elm Street from the 1892 county courthouse. (Dallas Municipal Archives.)

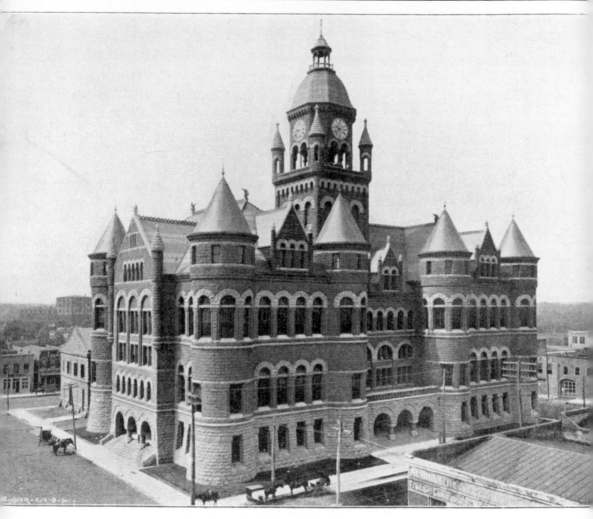

DALLAS COUNTY COURT HOUSE.

The fifth Dallas County Courthouse to occupy this site since 1846 is a massive red sandstone and granite structure that expressed the newfound economic prowess of the state's largest city when it was completed in 1892. The architect was M.A Orlopp of Little Rock, Arkansas, whose design reflected a strong influence of H.H. Richardson's Romanesque style. (Dallas Firefighters Museum.)

The original central tower, 205 feet in height, was removed in 1919 due to structural instability. It was reinstalled when the building was renovated between 2005 and 2007 for use as a local history museum. "Old Red," as the building is affectionately called, served as the center of county government until 1928. (*Dallas Morning News.*)

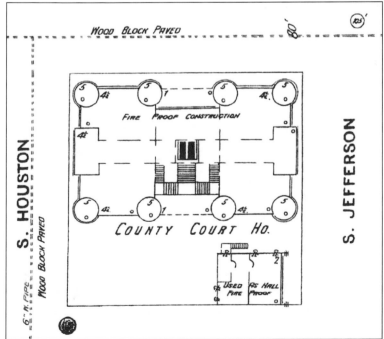

The plan of the courthouse is outlined in this 1899 Sanborn fire map. A grand staircase was located in the center of the structure, beneath the tower. District courtrooms were located in the building's four corners, with jury rooms and the clerks' offices housed in the eight round turrets. (Texas State Library.)

The Dallas County Clerk's Office stood on the courthouse grounds facing Jefferson (later Record) Street from its construction in 1895 to its demolition about 1968 to make way for an underground parking garage. The actual clerk's office moved several times, eventually to the Dallas County Records Building one block away. (Dallas Heritage Village.)

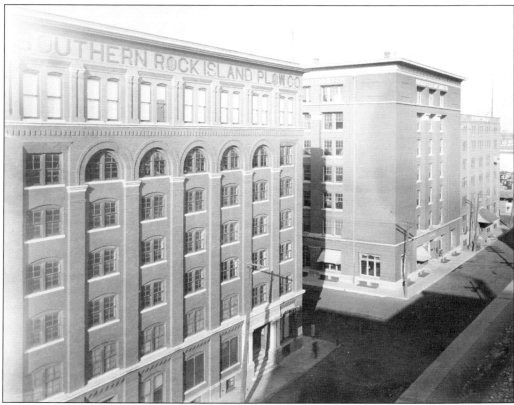

This c. 1905 photograph looking east along Elm Street portrays the character of Dallas's burgeoning warehouse district, which developed in response to construction of the Texas & Pacific Railroad tracks along Pacific Avenue. Many out-of-state farm machine and supply dealers established branch offices in Dallas beginning in the 1870s. There developed a strong demand for multistory warehouse structures to store such products as plows, cultivators, wagons, carriages, buggies, and other agricultural implements. Most of the large warehouses erected in the first decade of the 20th century were directly related to the farm equipment business. Three of these buildings can be seen in this photograph. They are, from left to right, the Southern Rock Island Plow Company (later, the Texas School Book Depository), the John Deere Plow Company, and the Southern Supply Company. (*Dallas Morning News.*)

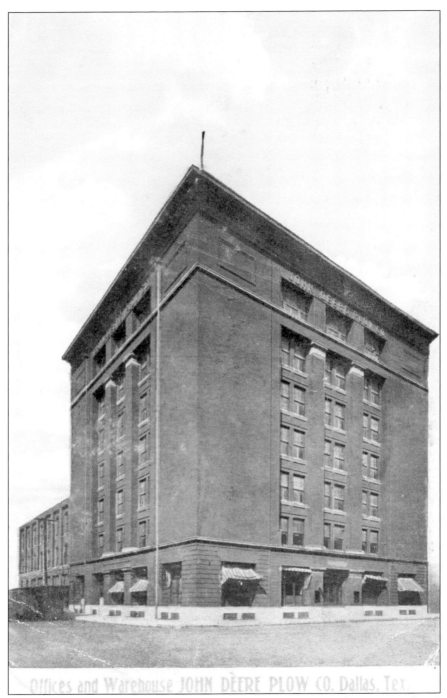

Offices and Warehouse JOHN DEERE PLOW CO. Dallas, Tex.

The John Deere Plow Company (now 501 Elm Street) was constructed in 1902 as the Kingman Implement Company, one of the most architecturally significant buildings in the West End Historic District. The architect firm Hubbell and Greene confidently interpreted the Chicago commercial style with their adaptation of Sullivanesque details, employing form and massing unique in Dallas architecture. Also called the Dal-Tex Building, it served as the office of assassination witness Abraham Zapruder's apparel manufacturing business, Jennifer Juniors, Inc. (Dallas Heritage Village.)

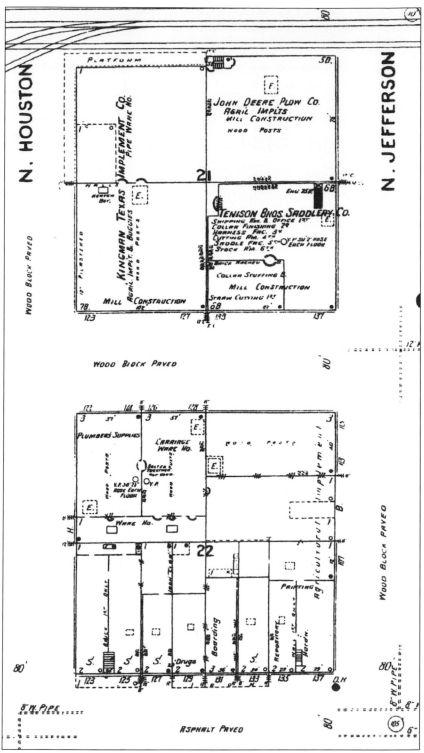

This Sanborn map from 1905 shows more of the warehouse district, including the John Deere Plow Company and the Tension Brothers Saddlery Company. (Texas State Library.)

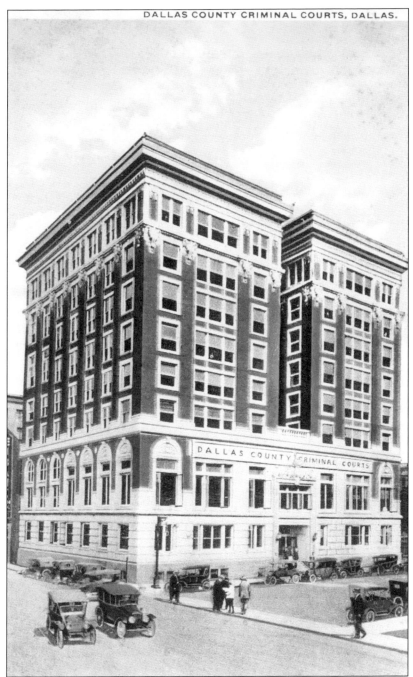

By 1912, the need for a new county jail and criminal courts facility was an important issue facing the county commissioners. The existing jail was on the site proposed for the new Union terminal, making a replacement jail facility necessary. A grand jury was charged with studying the current jail and reported on its shocking, intolerable conditions. Land was acquired for a new jail at the northeast corner of Main and Houston Streets. Local architect H.A. Overbeck designed the 10-story building, which stood in sharp stylistic contrast to the old courthouse across the street. (Dallas Heritage Village.)

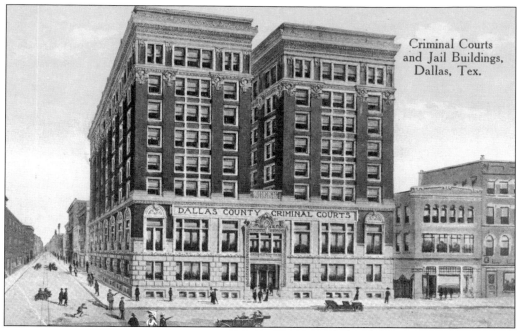

Criminal Courts
and Jail Buildings,
Dallas, Tex.

DALLAS COUNTY CRIMINAL COURTS

Behind the richly detailed Renaissance Revival facade, the building's architect created a programmatically and technically innovative design for this early justice facility, which once counted as its residents Clyde Barrow and the mobster "Pretty Boy" Floyd. Lee Harvey Oswald was being transferred to this jail when he was shot by Jack Ruby on November 24, 1963. Ruby (left) was incarcerated here, and his trial was held in one of the courtrooms on the second floor. When it opened in 1915, the $675,000 facility was hailed as the most humane and modern jail in the United States by a social welfare expert from Boston. (Above, Dallas Heritage Village; left, Dallas Municipal Archives.)

In 1933, seasoned criminal Harvey Bailey staged a daring escape from the "escape-proof" Dallas County Jail. Harvey had been arrested by the FBI at a farm north of Fort Worth, where he was returning a machine gun borrowed from George "Machine Gun" Kelly that Bailey had used in a bank heist. The FBI took Bailey to the jail in Dallas, where he was locked in a cell on the ninth floor. While Bailey was away from his cell being arraigned for a kidnapping he purportedly masterminded in Oklahoma City, a sheriff's deputy secreted a Colt .45 revolver and hacksaw blades under his pillow. Bailey cut away three bars near the bottom of his cell door, then squeezed through a small opening (in the photograph at right at the far left end of the jail corridor, covered by a towel). After locking up officers in various parts of the building, Bailey was able to make his way to ground level by elevator, eventually emerging outside to a waiting car. Bailey was soon apprehended in Ardmore, Oklahoma, and was transported to Oklahoma City, where he was tried and convicted of the kidnapping there. (Both, Dallas Municipal Archives.)

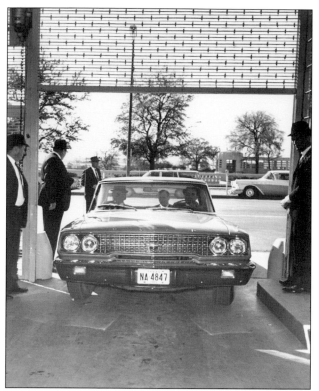

Jack Ruby, Lee Harvey Oswald's assassin, was held in the Criminal Courts Building and tried there in the court of the Honorable Joe Brown. Some believe Ruby killed Oswald to keep him from revealing a larger conspiracy. Ruby, however, denied the charge, maintaining that he was acting out of patriotism. In March 1964, Ruby was found guilty and sentenced to death. He died in 1967. At left is Ruby arriving at the Criminal Courts Building garage. Below are jurors from the same trial. Note that Dealey Plaza is visible in both photographs. (Both, *Dallas Morning News*.)

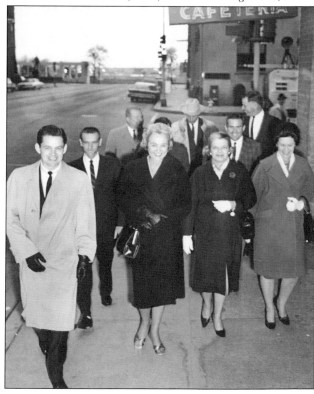

After the jail was completed in 1915, county commissioners next turned their attention to the need for a new hall of records. A site at the corner of Main and Jefferson Streets, adjacent to the County Jail and Criminal Courts Building, was purchased, and local architects Lang and Witchell were hired for the building's design. Otto Lang was an early proponent of developing the triple underpass project as a city park. The architects designed a six-story, block-long building with a Neo-Gothic Revival facade. The total cost of the new facility, including land, was $890,000. Before the building opened in 1928, the *Dallas Morning News* announced the impending transfer of legal documents "hoary with age" to the new records hall. (Right, Dallas Public Library; below, Dallas Municipal Archives.)

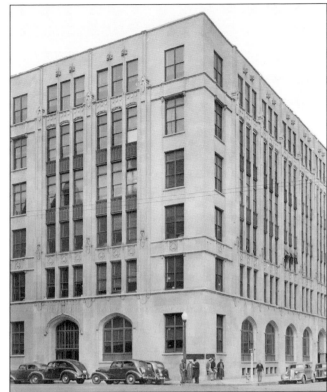

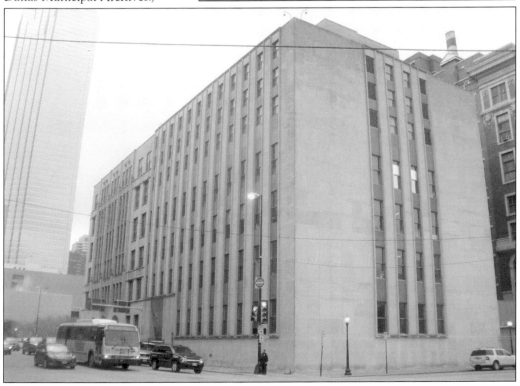

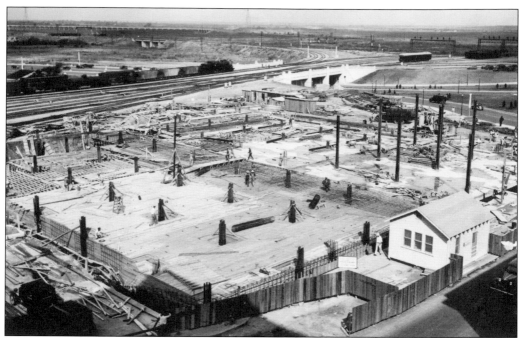

As the triple underpass project was nearing completion in 1936, the federal government demolished a third block of old buildings on Houston Street to construct a $1 million postal substation. The site of the new facility, which was designed by the architecture firm Lang & Witchell, bordered Dealey Plaza on the south. In the above photograph of the construction progress, the recently completed triple underpass can be seen in the background. (Above, *Dallas Morning News*; below, Jeff Dunn.)

When it was completed in 1937, the five-story postal facility was hailed as the most modern mail-processing center in the country. Lee Harvey Oswald rented a postal box in this building, which he utilized to order the rifle used in the assassination. The postal substation (later called the Terminal Annex) overlooks Dealey Plaza (left). The Burlington-Rock Island Railroad's Sam Houston Flyer rests on top of the triple underpass. Union Station is in the background. (Museum of the American Railroad.)

Two murals by the regionalist painter Peter Hurd can be found in the lobby of the Terminal Annex. Hurd studied under the illustrator N.C. Wyeth and executed murals in West Texas throughout his career. These two murals were created under a New Deal program that commissioned art for federal buildings, especially post offices, throughout the 1930s and early 1940s. Hurd's murals for the postal substation, *Airmail Over Texas* (left) and *Pioneer Homebuilders* (below), depicted scenes of local history and industry. (Both, Noah Jeppson.)

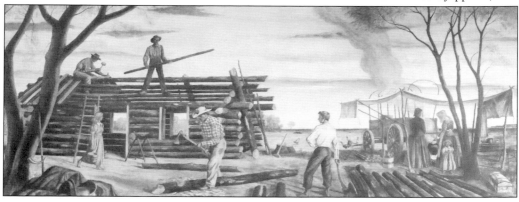

An often-overlooked component of the buildings that surround Dealey Plaza is this railroad-switching tower, built by the Missouri-Kansas-Texas Railroad in 1916. With the construction of Union Station in 1914, over 19 miles of track were laid in the immediate vicinity. Two rail yards, each with line-switching towers equipped with electro-pneumatic equipment, were built to the north and south of the station. The north tower, seen here, was occupied by "tower man" Lee Bowers Jr. on the day of the assassination. (Dallas Municipal Archives.)

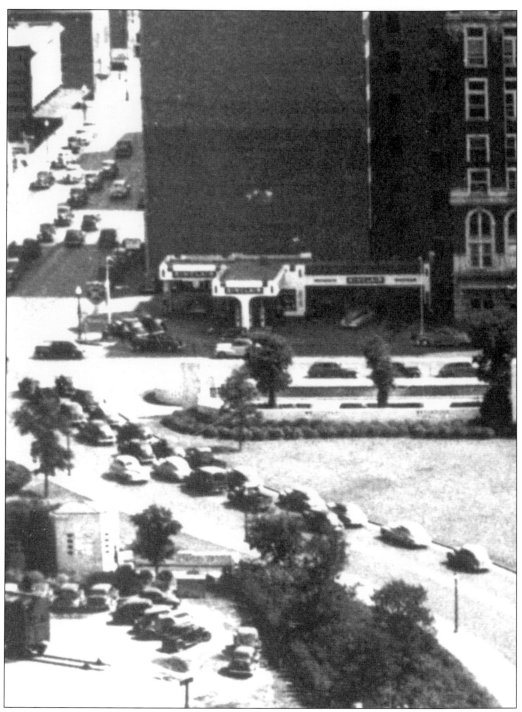

Gas stations in the West End were plentiful in the early 20th century, but by 1942, one of the last in the area was this Sinclair station, located at the southeast corner of Elm and Houston Streets, diagonal to the Texas School Book Depository. It was demolished by 1954 to make way for the County Records Building expansion. (Dallas Municipal Archives.)

Four

THE TEXAS SCHOOL
BOOK DEPOSITORY

The redbrick building on the northeast corner of Dealey Plaza has stood in this location since 1901. It has had multiple owners and names over the past 114 years. It was the Texas School Book Depository in November 1963, when the motorcade of Pres. John F. Kennedy slowed to make a sharp turn from Houston Street onto Elm Street, directly in front of the building. After standing empty for many years, Dallas County purchased the structure from a subsequent owner and renovated it as the County Administration Building in 1981. The top two floors of the structure remained empty until 1989, when The Sixth Floor Museum opened. Millions of visitors have made a pilgrimage to Dealey Plaza to understand the tragic event that occurred there. This photograph was taken in November 1963, days after the assassination. Mourners can be seen on the left side of the image, on the lawn that slopes upward to the northwest pergola. (*Dallas Morning News.*)

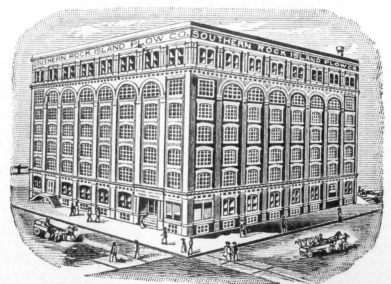

Southern Rock Island Plow Company

MANUFACTURERS AND JOBBERS IN

Implements, Wagons, and Vehicles

Elm and Houston Streets

The Southern Rock Island Plow Company was established in 1899 as a regional branch of B.D. Buford & Company of Chicago to sell agricultural implements to the farmers of the prodigious North Texas region. It was the second most profitable branch house for the company, boasting a catalog heavily dedicated to cultivating Southern crops like cotton. This is an advertisement from 1905. (Dallas Public Library.)

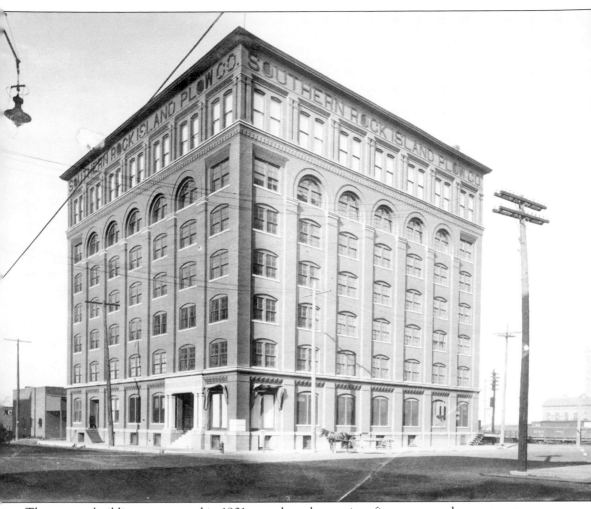

The present building was erected in 1901 to replace the previous five-story warehouse structure, which had been struck by lightning and burned down in a spectacular conflagration earlier that year. This is a view from about 1910. (*Dallas Morning News.*)

This building was one of the earliest and largest of the multitude of farm implement warehouses built north of Elm Street after the turn of the 20th century. A spur from the Texas & Pacific Railroad line running along Pacific Avenue brought agricultural products directly to the warehouses located in the district. The structures built after 1900 exhibited a strong influence of the Chicago School and commercial styles of architecture, bringing a progressive design spirit to Dallas that reflected the strong economic and architectural ties between the two cities. To celebrate the completion of its structure, the Southern Rock Island Plow Company hosted a dance in the new building, with over 100 couples in attendance. Streetcars and other means of conveyance were provided for the attendees when the party disbursed at 2:30 a.m. Above is an undated commemorative coin. Below is a sample of the company's elegant letterhead. (Above, John Tutor Collection/The Sixth Floor Museum at Dealey Plaza; below, Jeff Dunn.)

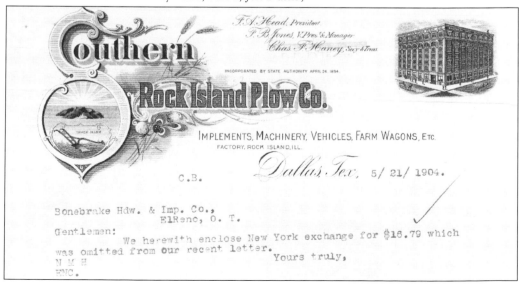

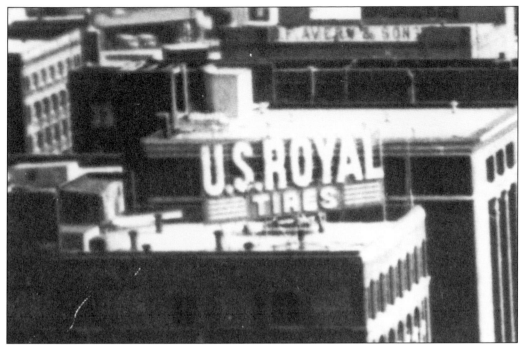

The Texas School Book Depository had a variety of signs on its roof after Dealey Plaza was completed in 1941. The signs were at least two stories in height and were angled toward State Highway No. 1 to face incoming traffic from Fort Worth. In addition to the Hertz sign, which was prominent in 1963, U.S. Royal Tires (above) and Ford (bottom) advertised on top of the building in 1942 and 1955, respectively. (Above, Dallas Municipal Archives; below, Dallas Public Library.)

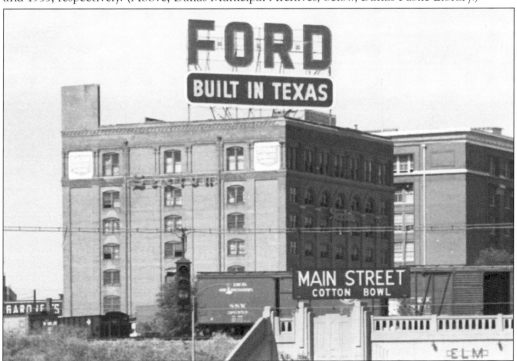

In 1979, the Hertz Rent-A-Car sign was removed from the roof of the depository and stored in the building's basement, as seen in this c. 1983 photograph. It remains in the collection of The Sixth Floor Museum. (*Dallas Morning News.*)

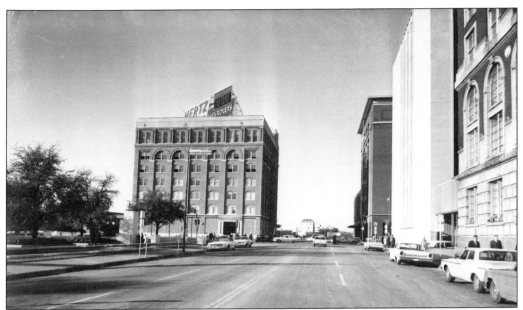

In these crime scene photographs taken by the Dallas Police Department after the assassination, the Texas School Book Depository stands in visual isolation from the other buildings that surround Dealey Plaza. This was the view that confronted the presidential motorcade on November 22, 1963, as it made the right-hand turn from Main Street onto Houston Street. The ground-level windows of the depository building had previously been filled in with concrete block. The Dallas County Jail and Criminal Courts Building are visible on the right in the above photograph. (Both, Dallas Municipal Archives.)

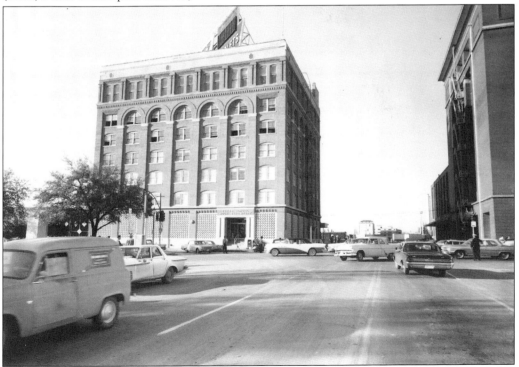

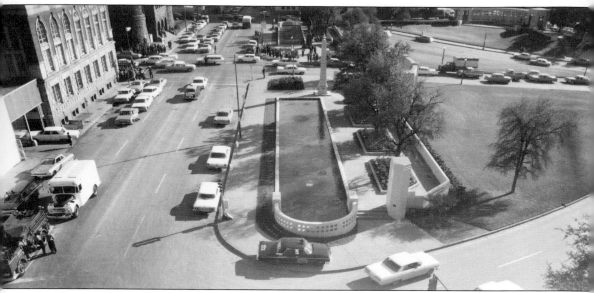

This was the assassin's view from the sixth-floor window of the Texas School Book Depository. President Kennedy's limousine entered Dealey Plaza on Main Street, at the top left of this image, proceeded directly toward the depository along Houston Street, then slowed to make a left turn onto Elm Street, directly beneath the assassin's perch. The reflecting basins built by the National Youth Administration in 1937 stretch along Houston Street in the center of the photograph. (Dallas Municipal Archives.)

These crime scene photographs of the depository's sixth floor show the barricade of boxes stacked around the corner window to conceal the assassin's activities from other employees in the hours preceding the assassination. (Both, Dallas Municipal Archives.)

Concealed from view within the building, the assassin positioned three boxes on the floor and windowsill. This allowed him to aim and fire toward the presidential limousine as it proceeded down Elm Street toward the triple underpass. (Dallas Municipal Archives.)

In this evidence photograph, shell casings can be seen on the floor next to the brick wall under the window. (Dallas Municipal Archives.)

In 1970, D. Harold Byrd, the owner of the Texas School Book Depository, put the building up for sale. Briefly owned by Nashville promoter Aubrey Mayhew and damaged in a fire, it returned to the Byrd family in 1972. In a bizarre twist, in 2007, Mayhew attempted to sell through online auction the sixth-floor window from which the sniper shot the president, claiming he had removed it from the building and had it in his possession. Byrd's son countered, saying *he* owned the true window and would auction it off to the highest bidder. After lawsuits over ownership and the death of Mayhew in 2009, the dispute remains unsettled. (Dallas Municipal Archives.)

The Dallas Police Department extensively documented the crime scene, including photographing the stairway (above) and the building's cafeteria (below). (Both, Dallas Municipal Archives.)

Only a minute after the assassination, Dallas police officer Marion Baker observed Lee Harvey Oswald on the second floor of the depository in this break room. According to Baker, Oswald had a can of soda in his hand. Had he been on the sixth floor minutes before? This question has eluded researchers for 50 years. (Dallas Municipal Archives.)

From the west side of the triple underpass, the Texas School Book Depository merges into the visual backdrop of the buildings that surround Dealey Plaza. After the shots were fired, the presidential limousine drove through the underpass and turned right to enter Interstate 35 on its final journey to Parkland Hospital, located four miles north of downtown Dallas. (*Dallas Morning News*.)

This 1963 photograph of the rear facade of the Texas School Book Depository shows the railroad sidings that were still being utilized by the warehouses in the district in the 1960s. (*Dallas Morning News.*)

Near the Texas School Book Depository on the grassy knoll is a five-foot-tall wooden stockade fence approximately 169 feet long. In 1964, the Warren Commission concluded that only three shots were fired, all from behind the president, all from the school book depository. In 1979, an investigation conducted by the House Assassinations Committee acknowledged that a possible fourth shot, which missed, had been fired from behind the fence. (Both, Dallas Municipal Archives.)

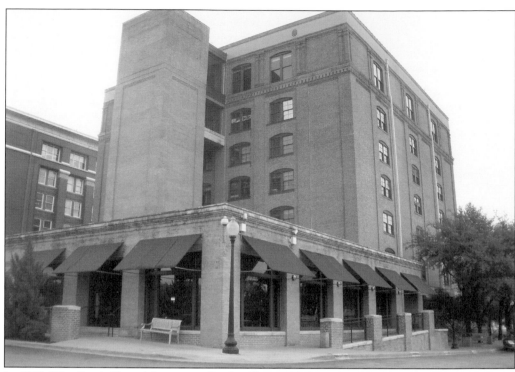

In 1989, The Sixth Floor Museum at Dealey Plaza added a ground-level visitor's center behind the building and an external elevator tower that took visitors to the sixth and seventh levels. The elevator addition was very controversial with Dallas preservationists. The museum's popularity and innovative programming has helped preserve the history of Dealey Plaza in a respectful manner. (Both, Dallas Municipal Archives.)

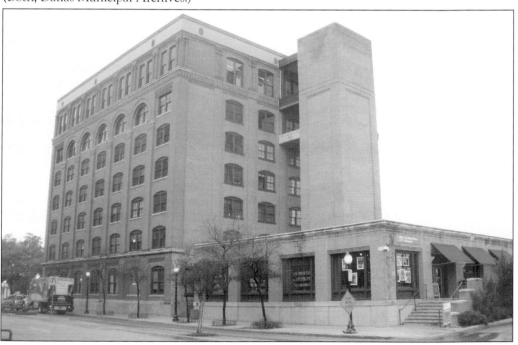

Five

DEALEY PLAZA AND JOHN F. KENNEDY

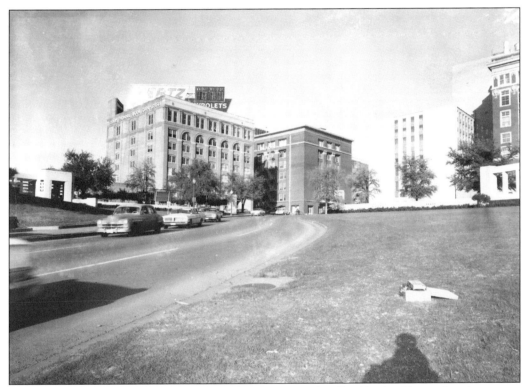

In spite of its relevance to the origins and early history of Dallas, Dealey Plaza is best known as the site of the assassination of Pres. John F. Kennedy on November 22, 1963. The president was visiting Dallas as part of a statewide tour to shore up the divided Texas Democratic Party. After stops in San Antonio at Brooks Air Force Base and at Rice University in Houston the previous day, Kennedy spoke at the Fort Worth Chamber of Commerce and flew to Dallas for a downtown parade and a planned luncheon speech at the Dallas Trade Mart. The president was then to fly to Austin, where there would be an afternoon parade and then a weekend at the LBJ ranch. (Dallas Municipal Archives.)

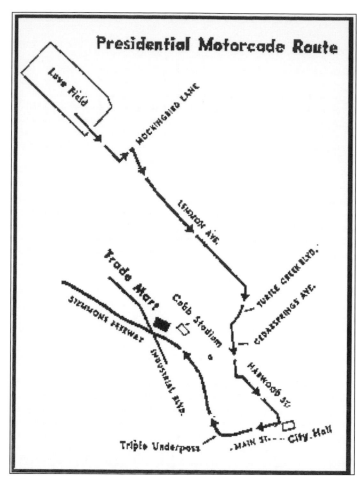

Presidential Motorcade Route

Kennedy's motorcade route, shown here, was published in the *Dallas Morning News.* The Dallas parade's end was scheduled for Dealey Plaza. (*Dallas Morning News.*)

After the Fort Worth Chamber speech, Pres. John F. and First Lady Jacqueline Kennedy landed at Love Field, where the motorcade began. The entourage took a left turn from the south end of the airport to Mockingbird Lane and a right onto Lemmon Avenue. It proceeded toward downtown, making a right at the split on Turtle Creek Boulevard, then straight on Cedar Springs Road, left on Harwood Street, and right on Main Street, where the bulk of the parade watchers were gathered. (*Dallas Morning News.*)

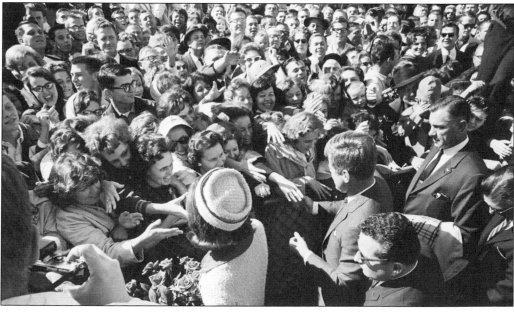

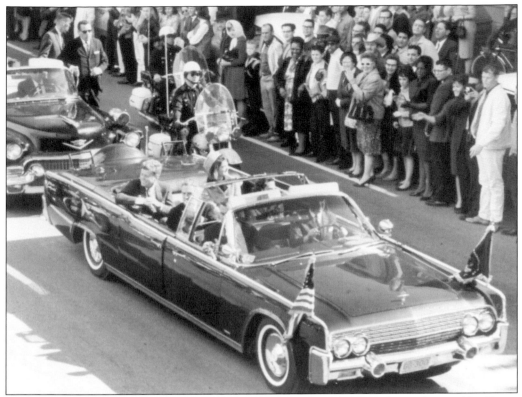

The president stopped two times to shake hands with schoolchildren, first at Lomo Alto Drive and Lemmon Avenue and a second time near St. Ann's Catholic School at the corner of Cedar Springs and Harwood Streets. (Both, *Dallas Morning News.*)

After traveling much of the length of Main Street, the motorcade turned right on Houston Street, where it would take a sharp left onto Elm Street into Dealey Plaza. After driving through the triple underpass, the motorcade was to veer to the right to take up ramp to North Stemmons Freeway. The motorcade's destination was the Dallas Trade Mart at 2100 North Stemmons Freeway. This is the corner of Houston and Elm Streets where the limousine turned. (Dallas Municipal Archives.)

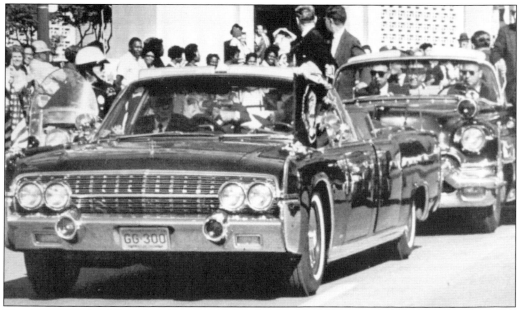

The last seconds of President Kennedy's life were spent waving to cheering crowds in Dealey Plaza. In this image, Secret Service agents look in the direction of the Dal-Tex Building. (*Dallas Morning News.*)

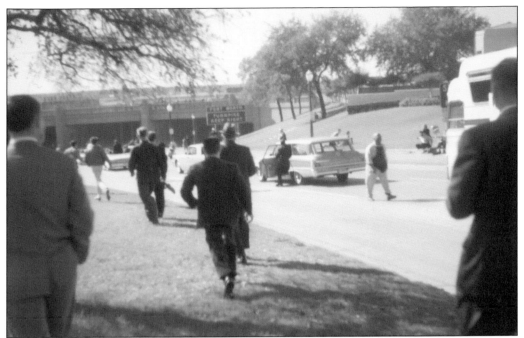

At 12:29 p.m. CST, the presidential limousine entered the plaza, documented by over two dozen known and unknown amateur and professional photographers. In the limousine with the president were the first lady, Texas governor John Connally and his wife, Nellie, as well as a driver. In the five cars that followed, passengers included Vice Pres. Lyndon Johnson, Ladybird Johnson, and Sen. Ralph Yarborough. A press corps bus trailed the motorcade. Most witnesses recall hearing three shots, with the last two distinctly much closer together than the first two. After the fatal shots, the limousine driver and police motorcycles turned on their sirens and raced at full speed to Parkland Hospital, arriving at about 12:38 p.m. Spectators scattered after hearing the shots, some hitting the ground to avoid danger. Others ran both away and toward perceived shooting sources. Dallas Police Department escorts and Secret Service agents immediately looked for possible directions as well. In the photograph below, the press corps bus lags behind by a few seconds. (Both, Phil Willis Collection/The Sixth Floor Museum at Dealey Plaza.)

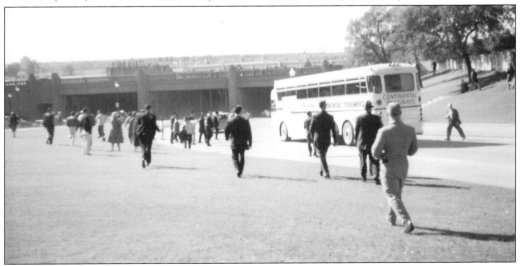

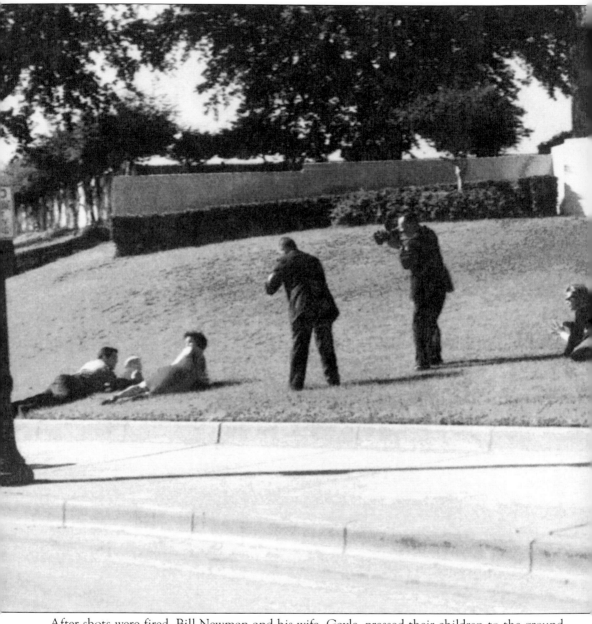

After shots were fired, Bill Newman and his wife, Gayle, pressed their children to the ground along the grassy knoll and shielded them with their bodies. It is one of the most indelible images of that day. (Cecil Stoughton, White House/John F. Kennedy Presidential Library.).

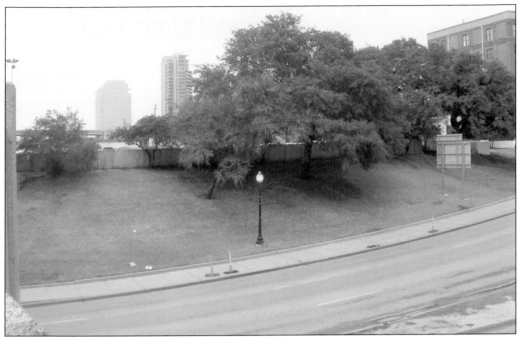

The grassy knoll is a small, sloping hill inside the plaza that was to the right of President Kennedy at the time of the shots. The name was coined by reporter Albert Merriman Smith of UPI in his second dispatch from the radio-telephone in the press car: "Some of the Secret Service agents thought the gunfire was from an automatic weapon fired to the right rear of the president's car, probably from a grassy knoll to which police rushed." This was repeated on national television by Walter Cronkite in his second CBS News bulletin. At left in the photograph below is the fence located at the top of the grassy knoll. The fence has been a source of speculation regarding multiple assassins. Portions of the fence have been replaced several times. (Both, Dallas Municipal Archives.)

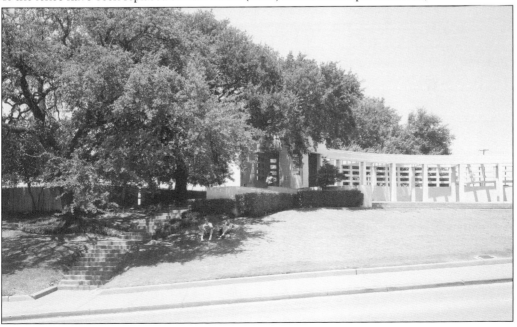

Another source of speculation concerns the traffic light pole situated at the northwest corner of Elm and Houston Streets. Some researchers are convinced an assassin's bullet missed the motorcade and zinged off the traffic light's support arm. In 2012, researcher Max Holland (at right in the photograph below) examined the pole's arm for evidence. (Both, Dallas Park and Recreation Department.)

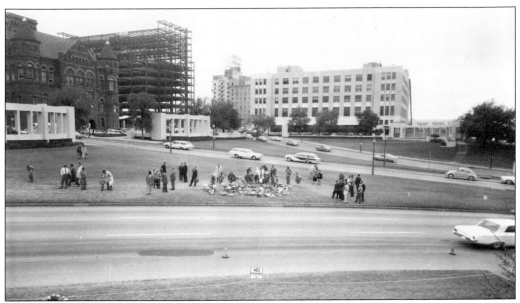

Almost immediately, makeshift memorials to the slain president were erected in Dealey Plaza. After the initial police department crime scene investigation, wreaths and flower arrangements were assembled throughout the plaza but especially near the north pergola, overlooking the exact spot of the president's death. In these photographs, citizens visit and express their grief with flowers and US flags. In the above photograph, the George L. Allen Sr. Civil District Courthouse can be seen under construction. (Above, Dallas Municipal Archives; below, *Dallas Morning News*.)

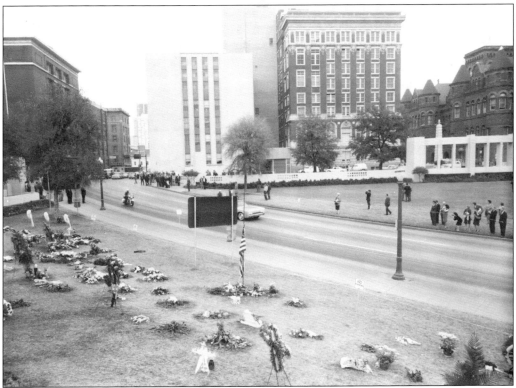

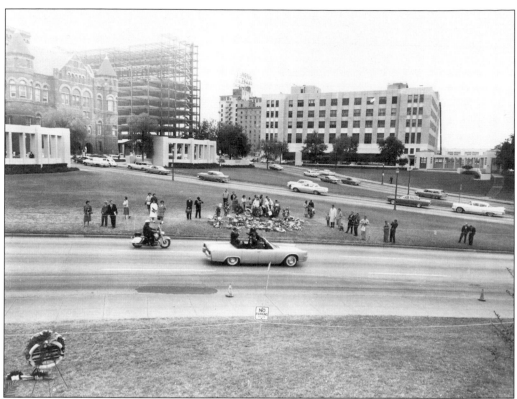

The Secret Service, FBI, and Warren Commission all attempted to determine the origin and timing of the shots that killed President Kennedy and wounded Governor Connally. As seen in these photographs, the Secret Service conducted a re-creation in late 1963 as the nation grieved. While sparse and inaccurate compared with subsequent efforts, the 24 minutes of black-and-white footage taken by the Secret Service was the first attempt to use motion pictures to solve the mystery of JFK's murder. (Both, Dallas Municipal Archives.)

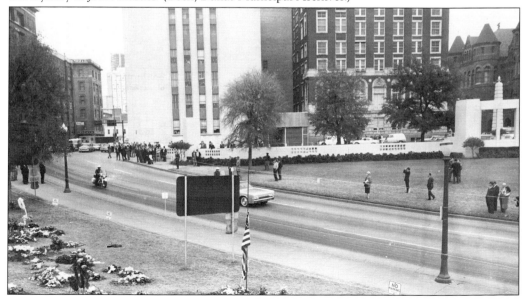

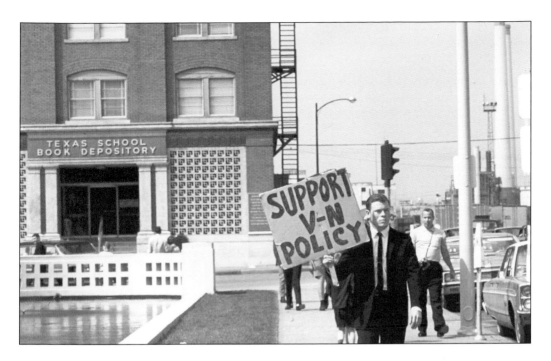

After 1963, Dealey Plaza became a focal point for a number of events. In the above photograph from 1969, a protestor decries US involvement in Vietnam. Below, a large group gathers at a John F. Kennedy memorial event on the 30th anniversary of the assassination in 1993. (Above, George Reid Collection/The Sixth Floor Museum at Dealey Plaza; below, Ronald D. Rice/The Sixth Floor Museum at Dealey Plaza.)

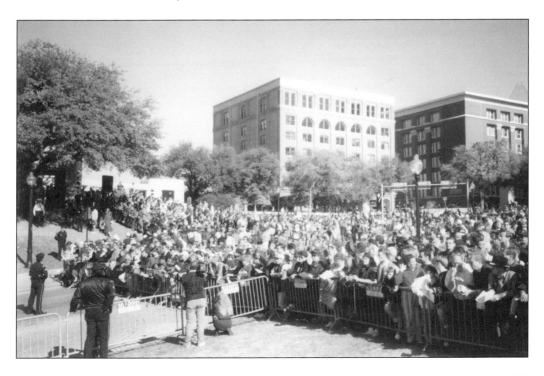

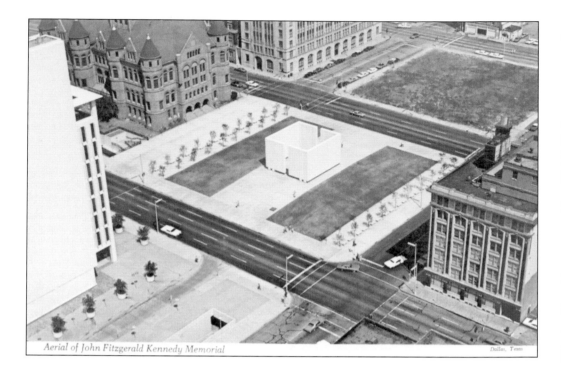

Aerial of John Fitzgerald Kennedy Memorial Dallas, Texas

Dallas civic leaders wrestled emotionally over how to honor the slain president. Stanley Marcus, of Neiman-Marcus retail fame, was prominent in the selection of famed American architect and Kennedy family friend, Philip Johnson, to design a memorial. The John F. Kennedy Memorial Plaza is located one block east of Dealey Plaza, between Main and Commerce Streets, on land donated by Dallas County. (Both, Dallas Heritage Village.)

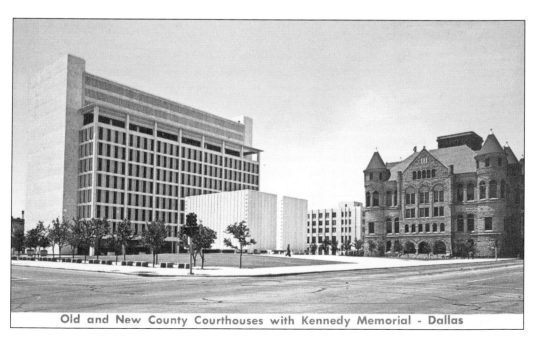

Old and New County Courthouses with Kennedy Memorial - Dallas

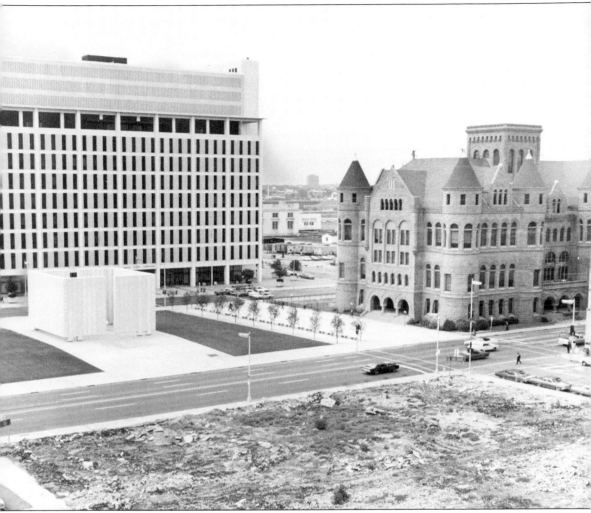

The Kennedy plaza was the first memorial designed by Johnson and was approved by Jacqueline Kennedy. Johnson called it "a place of quiet refuge, an enclosed place of thought and contemplation separated from the city around, but near the sky and earth." The cenotaph and the surrounding square, funded entirely by citizens, were dedicated on June 24, 1970. (*Dallas Morning News.*)

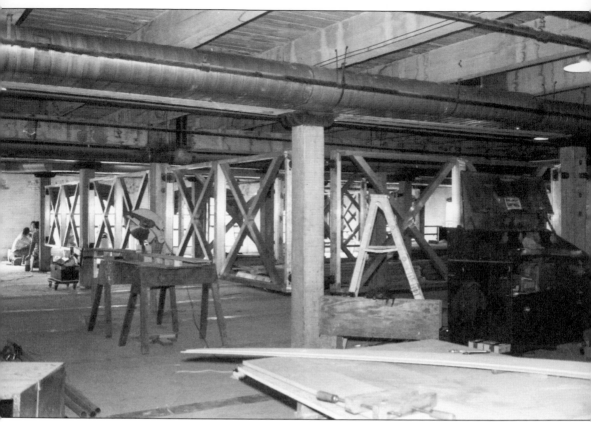

Opened in 1989, The Sixth Floor Museum at Dealey Plaza has the following functions: chronicling the assassination and legacy of Pres. John F. Kennedy, interpreting the Dealey Plaza National Historic Landmark District and the John F. Kennedy Memorial Plaza, and presenting contemporary culture within the context of presidential history. It has been visited by millions since its opening. This photograph shows the museum under construction in 1988. (Institutional Archives/The Sixth Floor Museum at Dealey Plaza.)

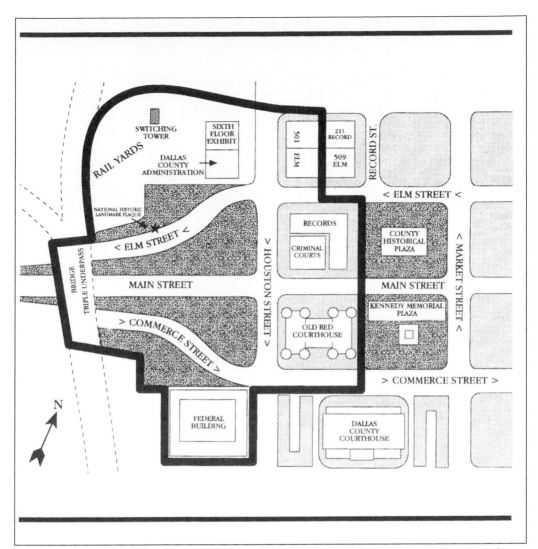

Dealey Plaza is visited by over two million people annually, second in Texas only to the Alamo. The Texas School Book Depository building was recognized in 1980 by the Texas Historical Commission as a Texas Historic Landmark. To preserve Dealey Plaza and its surrounding buildings, the federal government designated the area a National Historic Landmark District. The district is comprised of the 3.07-acre Dealey Plaza Park, the surrounding buildings facing the park, the triple underpass and its bridge, and a part of the rail yards north of Elm Street, including the railroad-switching tower. Secretary of the Interior Bruce Babbitt signed the official designation of the site, and formal dedication ceremonies were held in Dealey Plaza on November 22, 1993, before a crowd of over 3,000. (National Park Service.)

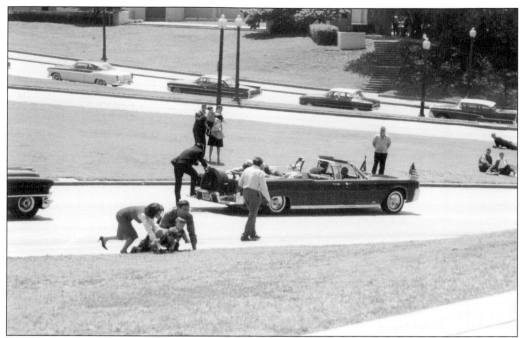

Oliver Stone's 1991 film *JFK* is the most famous of movies actually shot in Dealey Plaza. Dallas police rerouted traffic and closed streets for three weeks. The production spent $4 million to restore Dealey Plaza to 1963 conditions. Stone, in agreement with the City of Dallas, had temporary signs made and installed in Dealey Plaza. As an example of this, note, in the photograph below, the Stemmons Freeway sign to the left of center. (Both, Lovita Irby Collection /The Sixth Floor Museum at Dealey Plaza.)

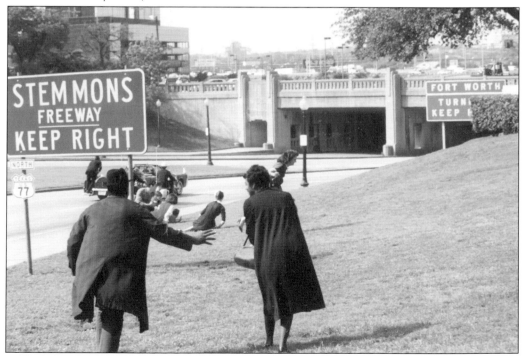

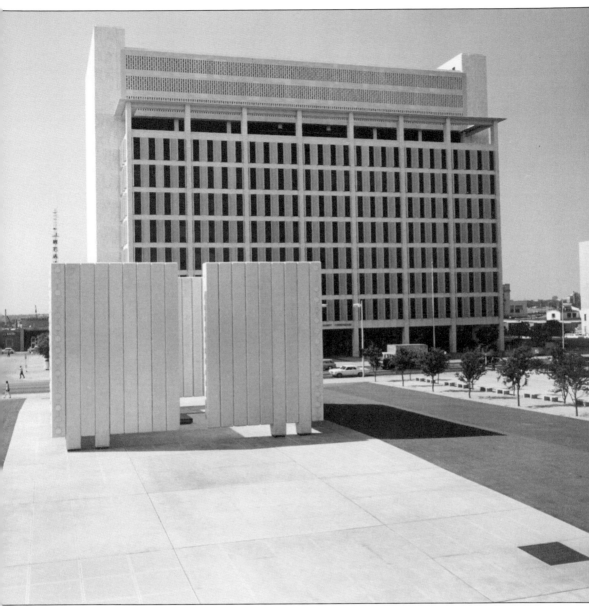

Buildings and monuments in the Dealey Plaza area have been carefully renovated. The 1892
Dallas County Courthouse (Old Red) was completely restored from 2001 to 2007 to its original
appearance and now houses the Old Red Museum of Dallas County History & Culture. To
commemorate the 30th anniversary of the Kennedy memorial, The Sixth Floor Museum oversaw
a full-scale restoration project to conserve the memorial. Its architect, Philip Johnson, guided the
restoration process. (Dallas Municipal Archives.)

A master plan for the restoration of Dealey Plaza was approved by the Dallas Park Board in 2003, to be paid for by a combination of public and private funding. Phase I occurred in 2009. Phase II was completed by Good Fulton & Farrell, Studio Outside, and JQ Engineering in 2013 in time for 50th anniversary commemorations of President Kennedy's death. Left, concrete is poured to renovate sidewalks and the reflecting pools at the north end of the plaza. The photograph below shows restoration of one of the pergolas. (Both, Dallas Municipal Archives.)

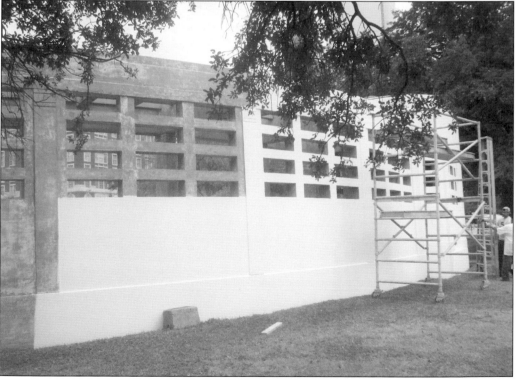

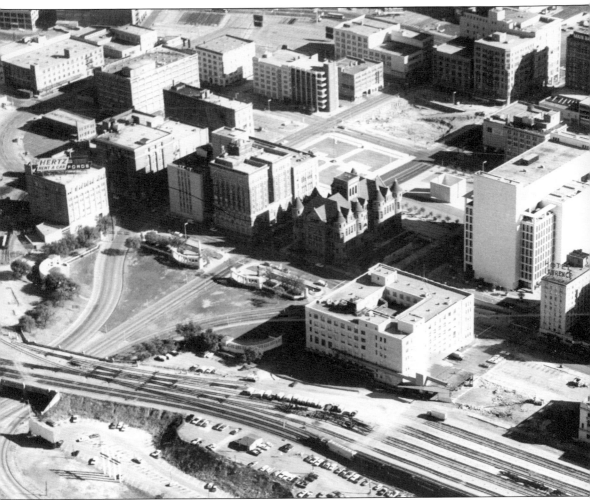

Dealey Plaza is an amazing physical space. It is quite literally the origin site of Dallas, now one of the largest cities in the United States. Dallas's rise from a frontier cabin to modern metropolis is a marvelous story in itself. But the plaza is also remembered with great sadness. It has taken many years for the citizens of Dallas and others to come to grips with its role in the tragedy of John F. Kennedy's death, but Dallas now recognizes the importance of this place where history was made and where history was changed. (Dallas Municipal Archives.)

DISCOVER THOUSANDS OF LOCAL HISTORY BOOKS FEATURING MILLIONS OF VINTAGE IMAGES

Arcadia Publishing, the leading local history publisher in the United States, is committed to making history accessible and meaningful through publishing books that celebrate and preserve the heritage of America's people and places.

Find more books like this at
www.arcadiapublishing.com

Search for your hometown history, your old stomping grounds, and even your favorite sports team.